PUTTING
people
IN YOUR paintings

Laurel Hart

NORTH LIGHT BOOKS
CINCINNATI, OHIO
www.artistsnetwork.com

ABOUT THE AUTHOR

Laurel Hart received her formal art training at the University of Utah, the Petersen Art Center, and the Salt Lake Community College in Salt Lake City, where she currently lives. She furthered her studies through workshops with nationally recognized artists such as Frank Webb, Arne Westerman, Alex Powers, Don Andrews and Alvaro Castagnet.

Laurel's paintings have been exhibited in many nationally juried shows, including those of the American Watercolor Society, the National Watercolor Society, Watercolor West, and Rocky Mountain National. Her work has been published in *The Artist's Magazine, Watercolor Magic* and the popular watercolor books, *Splash 8: Watercolor Discoveries* and *Splash 9: Watercolor Secrets*. She is the recipient of numerous art awards, including the prestigious Gold Medal of Honor in 2005 at the American Watercolor Society's 138th Annual International Exhibition.

She is a signature member of the National Watercolor Society, Watercolor West, Western Federation of Watercolor Societies, and the Utah Watercolor Society. Her paintings can be found in private art collections across the U.S. She is the mother of five children, her greatest source of accomplishment.

Other fine North Light Books are available from your local bookstore, art supply store or direct from the publisher.

11 10 09 08 5 4 3 2

DISTRIBUTED IN CANADA BY FRASER DIRECT
100 Armstrong Avenue
Georgetown, ON, Canada L7G 5S4
Tel: (905) 877-4411

DISTRIBUTED IN THE U.K. AND EUROPE BY DAVID & CHARLES
Brunel House, Newton Abbot, Devon, TQ12 4PU, England
Tel: (+44) 1626 323200, Fax: (+44) 1626 323319
Email: postmaster@davidandcharles.co.uk

DISTRIBUTED IN AUSTRALIA BY CAPRICORN LINK
P.O. Box 704, S. Windsor NSW, 2756 Australia
Tel: (02) 4577-3555

Library of Congress Cataloging in Publication Data
Hart, Laurel.
 Putting people in your paintings / Laurel Hart.
 p. cm.
 Includes index.
 ISBN-13: 978-1-58180-779-0 (hardcover : alk. paper)
 ISBN-10: 1-58180-779-1 (hardcover : alk. paper)
 ISBN-13: 978-1-58180-780-6 (pbk. : alk. paper)
 ISBN-10: 1-58180-780-5 (pbk. : alk. paper)
 1. Human figure in art. 2. Watercolor painting--Technique. I. Title.
 ND2190.H37 2007
 751.42'242--dc22 2006018343

Edited by Mona Michael
Designed by Wendy Dunning
Production art by Kathy Gardner
Production coordinated by Matt Wagner

Metric Conversion Chart

To convert	to	multiply by
Inches	Centimeters	2.54
Centimeters	Inches	0.4
Feet	Centimeters	30.5
Centimeters	Feet	0.03
Yards	Meters	0.9
Meters	Yards	1.1

Putting People in Your Paintings

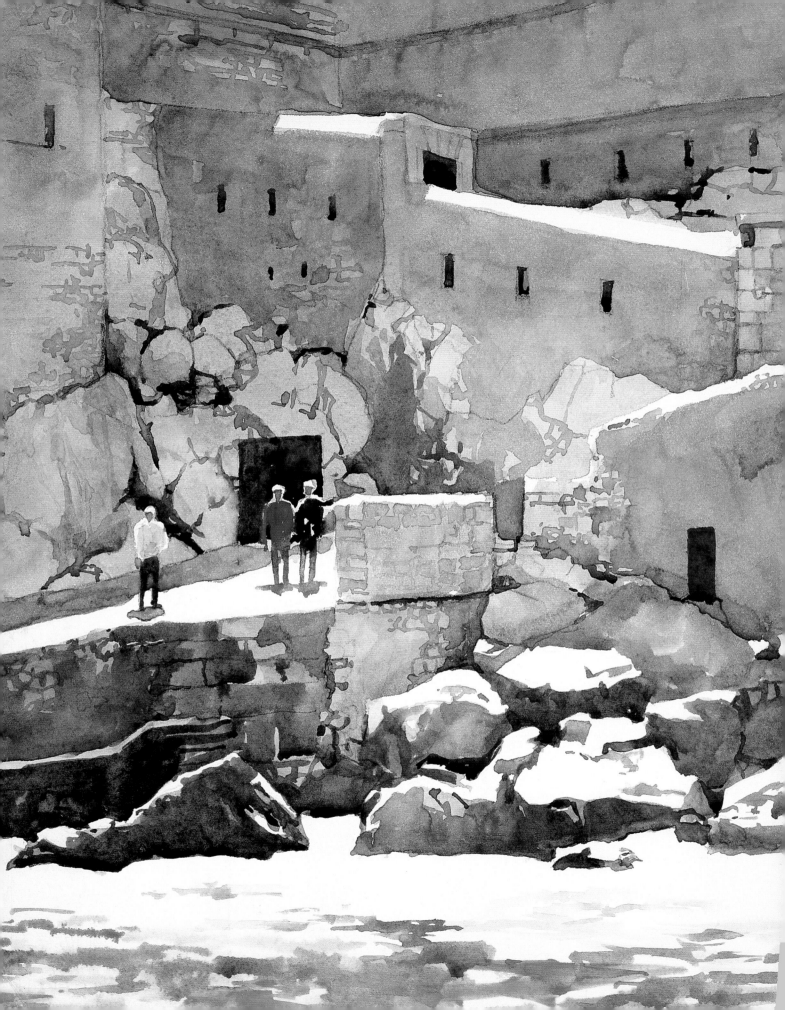

ACKNOWLEDGMENTS

My first introduction to watercolor came from seeing some beautiful paintings by Chris Heiner, a very gifted artist. It was like rediscovering a part of myself that had been hidden for a long time. My encounter with those paintings played an important role in developing my devotion to watercolor today. Thank you, Chris—your paintings on my kitchen wall still inspire me.

I express gratitude to my Creator, who I believe is an artist Himself and delights in helping us with our own creative pursuits. If we pay attention to this higher power working on our behalf, we will recognize little miracles occurring often in our lives. I acknowledge the opportunity to write this book as one of those gifts.

I wish to thank my parents, Stan and Leola Smith, both artists in their own right, for their unconditional love and support. I learned growing up that anything is possible through hard work and education and that "perfect or better" should be the motto in approaching any task.

To my extended family, thank you for cheering me on over the years, for supporting my shows and exhibits, for collecting my art and for showing up as subjects in many of my paintings.

This project would not have been possible without the help and support of each of my children, who are truly my best friends. Thank you, Brody, for helping me locate the photography equipment to photograph my artwork; Barry, for sharing your computer expertise and for your countless trips to drop off and pick up film, Tyler, for your helpful legal advice; and my beautiful daughters, daughters-in-law and granddaughters—Brittney, Brooke, Corine, Kathy, Makenzie and Eliza—for serving as my models whenever I needed you. To my new son-in-law Jake, thanks for the tennis matches that provided much-needed relief from the mental strain of looming deadlines.

I am also indebted to the important art teachers in my life—especially Harold Petersen, my first watercolor teacher—for giving me the confidence to keep coming to class. To the many teachers who don't even know I was their student, thank you for your classes, workshops and books.

I wish to express appreciation to Sue Valentine, Kayleen and Spence Pugh, and Clayton Williams for promoting and selling my work in their galleries.

I would also like to thank the staff at Borge Anderson Photo • Digital for their excellent reproductions of the finished artwork in the book and for the advice for photographing the demonstrations.

To Kevin Flynn, my studio landlord, thanks for providing my creative space and for going out of your way to take care of emergencies so that I could stay on schedule.

To Sheryl Thornton, who shares my studio space, I owe profound thanks for your influence not only on this book but on my life as well. I consider the crossing of our paths in the "brotherhood of art" as one of my most important blessings.

And finally I am truly indebted to my editor, Mona Michael, and the many people at North Light Books who have shown great faith in me by allowing me to run with this book. I appreciate Mona's professional direction when I didn't know my way, her patient consideration of my concerns and questions, and for allowing me extra time when I needed it most. I'm so grateful for her many hours of careful editing that allowed this project to come to life.

CHATEAU D'IF
14" × 20" (36CM × 51CM)

DEDICATION

This book is dedicated to my husband, Jim, the love of my life, whose wholehearted enthusiasm and support have made my creative dreams possible. I truly owe much of the success of this project to his help and encouragement.

Table of Contents

CHAPTER ONE
Getting Organized *10*

Supplies and setup • Maintaining a car kit • Using reference photos • Using a video camera for reference • Hart-Felt Insight: A painter's life

CHAPTER TWO
Simplify to Capture the Essence *18*

Exercise: Figures are patterns of light and shadow • Exercise: Mass the shadow shapes to find the shadow pattern • Exercise: Use the shadow pattern to paint a good likeness • Exercise: Simplify: Use negative painting • Exercise: Simplify: Use a strong light source against a dark background • Exercise: Simplify: Backlighting helps unify your subject • Exercise: 9 ways to soften and lose edges • Use an underpainting to tie your subject to the background • Hart-Felt Insight: You can best show truth by painting an illusion

CHAPTER THREE
Designing Strong Paintings *30*

What is design? • Seeing good design and composition • Viewfinders help determine format • 5 classic compositions to sell your subject • The focal point, or center of interest • Where to put the focal point • Putting it all together • Hart-Felt Insight: Thoughts on finding your own voice

CHAPTER FOUR
Value: 10 Ways to Get It Right *44*

1 | Use a ten-degree value scale • The foolproof way to paint shadow-side values • **2** | Identify patterns of darks and lights with value sketches • **3** | Work from black-and-white photos • **4** | Neutralize color to accentuate value • **5** | Squint at the subject • **6** | Create monochromatic paintings • **7** | Paint directly over a value sketch • **8** | Vary your value ratios • **9** | Place your subjects in strong light • **10** Overstate your values in watercolor • Hart-Felt Insight: Value does the work

CHAPTER FIVE
Color Mixing and Watercolor Technique *58*

Set the temperature • Color combinations that work • The watercolor laundry method • Demonstration: Use the watercolor laundry method to create a painting • Keys to applying pigment • Demonstration: The pull-down technique • Hart-Felt Insight: Thoughts on finding the perfect medium

CHAPTER SIX
Painting People From Life *74*

On-Location painting success • 5 steps for painting on location • Basic figure proportions • Demonstration: Using the spontaneous method: Working from a model • Demonstration: Semiworking

from life: Combining techniques • Hart-Felt Insight: Put life in your art

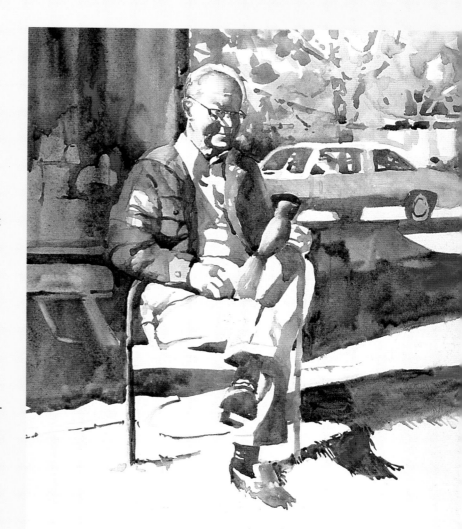

ELMER'S BLUEJAY
14" × 11" (36CM × 28CM)

INTRODUCTION

When Jamie Markle, editorial director for North Light Books, telephoned to ask me if I would like to write a book on painting people in watercolor, I couldn't have been more pleased. Not only was it to be a book about my favorite art subject, it was also to be a North Light Book, which would make it part of a family of art instruction books that already filled the favorite spaces on my own studio bookshelves.

At the same moment that I heard myself saying I would love to take on the project, my heart was seizing up with fear. Could I really do justice to such a huge undertaking? I might know something about painting people, but that didn't mean I knew how to write an instruction book on the subject. After I hung up, I called fellow Utah artist Carl Purcell, author of *Painting With Your Artist's Brain*, to ask how he had gone about it. The next day he e-mailed me this advice: "Each day before you begin your book, turn the whole thing over to God, let go of the anxiety, and go to it!" This book is literally the result of following that wise counsel.

If you are looking for a book about how to paint tight, photorealistic portraits, keep looking. But if you are interested in an approach to painting people that focuses on a fresh, impressionistic way of depicting figures in your paintings, this book will be of value to you.

In my many years of studying watercolor, I have come to discover a great secret: Before you can be taught to paint people accurately, you must learn how to see people abstractly. Careful observation and recording of the overall design of light and shadow patterns will yield a more accurate likeness of the model than trying to copy isolated details. Consequently I do not teach realistic figure drawing or present an intensive study of human anatomy here. Instead I will help you to see the abstract pattern of the figure as a whole, bypassing much of the detail; this is crucial to learning to paint impressionistic portrayals of people. By following my exercises and methods, you will gain the confidence and skill you need to render simple but believable figures that will truly add life to your watercolor paintings.

Successful paintings of people are not so much about creating detailed and perfect likenesses as they are about conveying the artist's feeling of love for the subject. The ability to express an emotional response to the model by capturing the essence of what appeals most to you is more important than a photorealistic rendering. If you convey your personal feelings, you will create for the viewers a bridge to your heart so they can see what's there. My goal is to give you the tools necessary to create passionate portrayals of people in your paintings.

How to Use This Book

This book consists of two distinct sections. Chapters 1–5 cover preliminary process. The preliminary process concerns arming yourself with the tools and basic skills necessary for putting people in your paintings. The last half of the book, chapters 6–9, deal with practical applications. These chapters are about putting that understanding and knowledge into practice as you begin creating finished paintings.

Understanding and expertise in both areas is vital to becoming a good artist, as one without the other will not get you very far. It is only when head and hand come together, when theory and practice converge in your work, that you will become successful as an artist.

AMAZON DANCERS
14" × 20" (36CM × 51CM)

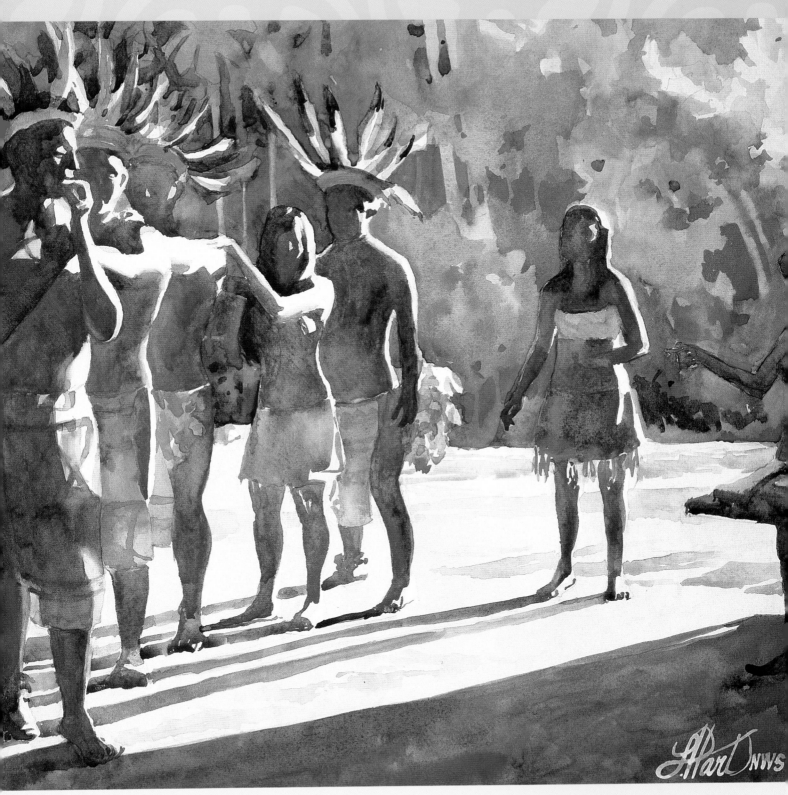

Realism doesn't always convey feeling

In this depiction of native Brazilian dancers, my focus was on the beautiful light shape connecting their bodies together. By capitalizing on the abstract design of the overall pattern of light and dark shapes and minimizing interior details of the figures, I was able to make the center of interest more pronounced.

Getting Organized

If you fail to plan, you plan to fail.

— UNKNOWN

I remember reading a funny story that supposedly happened during the the 1960s, when there was so much competition between the space programs of the United States and the Soviet Union. Apparently the Americans were trying to develop an antigravity pen that would work in weightless environments so the astronauts could write in outer space. After spending over a million dollars on the project, the Americans decided to see how their Soviet counterparts had handled the situation. The Soviets reported that they simply used pencils.

When it comes to getting the painting supplies and work space we feel we need to be successful as artists, we are sometimes a little like the Americans in the space race. We spend so much energy focusing on what we don't have that we overlook the resources we do have. Let's take a look at what we really need.

Use what you have
I painted this in a small, cramped basement room in my house long before I had access to the roomier studio I now enjoy. It's important to keep painting and not wait until conditions are perfect. In the end the artist who keeps working despite less than perfect conditions will prevail. So if the kitchen table is your studio for now, make the best of it and keep painting. This painting was accepted in the 1998 American Watercolor Society's 131st Annual International Exhibition.

MISSION SUNSET
21" × 14" (53CM × 36CM)

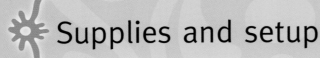

Supplies and setup

There's a saying: The bitterness of poor quality lingers far longer than the sweetness of low price. I'm a big-time bargain shopper, but there have been times when I've spent more money replacing cheap items than I would have spent buying higher-quality items to begin with. You don't have to buy the most expensive brands out there, but at least go for professional grade instead of student supplies. Ask your art supplier for help.

Pigments

Choosing paints really comes down to finding your personal favorites. There are many good watercolor brands, and individual colors vary from one make to another. Experiment to find the ones you like best. My favorites come from several different manufacturers. Keep in mind two main things as you search for pigments you like:

- Use professional grade for strong intensity and good mixing properties.
- Look for pigments with high lightfastness ratings, indicators of whether a color will fade in time through exposure to light. Most manufacturers print a pigment's rating on the tube.

My Favorite Pigments

The watercolor brands I use for the most part are Grumbacher, Winsor & Newton, and Cheap Joe's American Journey. Daniel Smith makes Transparent Oxide Red (my staple!). And Rembrandt makes another of my favorites: Transparent Oxide Yellow. If you can't find them, you can substitute Burnt Sienna and Raw Sienna, respectively. Ask your art supplier for recommendations as you experiment to discover your own personal favorites.

Brushes

Again, don't try to save money by refusing to buy decent brushes. It will only cause you grief in the long run. You don't have to own the most expensive set of

My Brush Choices

For detail work, I like Loew-Cornell Ultra Round natural-hair brushes. The no. 8 is my real workhorse for faces because of its ability to keep a sharp point. I also have a set of Royal and Langnickel synthetic brushes that I like for their springiness and durability. I use these a lot for lifting out areas. For backgrounds and larger wash areas I use Rekab series 320S Kazan Squirrel Mops. These are very versatile and hold lots of water for big, juicy washes and mingling color. They also maintain great points for fine detail lines.

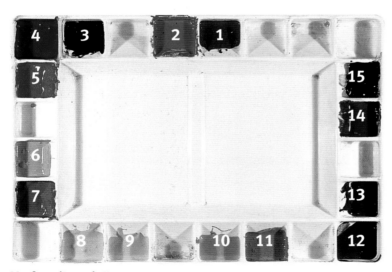

My favorite palette
Of the fifteen different pigments on my palette, there are six you won't catch me without. These are: Ultramarine Blue, Manganese Blue, Cadmium Red Medium, Alizarin Crimson, Transparent Oxide Red (or Burnt Sienna) and Yellow Ochre. These provide me with high-key and low-key (light and dark) versions of the primary colors, which is really all I need to create any painting. There are more warm colors (those leaning to yellow) on my palette than cool colors (those leaning to blue) for use in fleshtone mixtures when painting figures.

1 *Ultramarine Blue*, 2 *Manganese Blue*, 3 *Winsor Violet*, 4 *Permanent Alizarin Crimson*, 5 *Cadmium Red Medium*, 6 *Cadmium Orange*, 7 *Quinacridone Gold*, 8 *Aureolin*, 9 *New Gamboge*, 10 *Yellow Ochre*, 11 *Raw Sienna*, 12 *Transparent Oxide Yellow*, 13 *Transparent Oxide Red (or Burnt Sienna)*, 14 *Burnt Umber*, 15 *Sap Green*

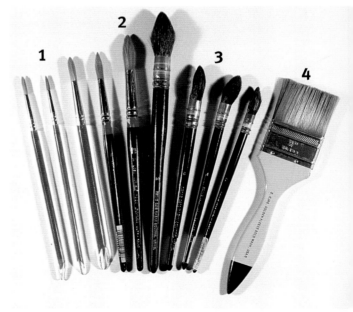

My brushes

1 *Synthetic rounds*, 2 *Natural-hair rounds*, 3 *Squirrel mops*, 4 *Flat wash brush*

The setup

The creative spirit flourishes in an ergonomically arranged studio space. Good organization will allow you the freedom to quickly get to work and have easy access to your equipment. A well-planned creative space will do more to feed your art spirit than anything else.

1 Plastic palette with divided mixing space and lid to keep paint from drying out, 2 Two water containers, one for rinsing brushes and one kept clean for rewetting areas, 3 Damp sponge to control amount of water in brush, 4 Paper towels to blot areas and remove water from brushes, 5 Spray bottle to wet paint and add texture to washes, 6 Table easel to keep painting board at an angle, 7 Adjustable drafting table to accommodate full-size paper, 8 Rolling adjustable-height office chair, 9 Art light, 10 Rolling taboret (on the left side of the chair because I'm left-handed), 11 Wooden strawberry crate to organize supplies, 12 Practice mat board to help analyze works in progress, 13 Small L-shaped mats for cropping, 14 Distilled water for spray bottles (prevents mold on paints)

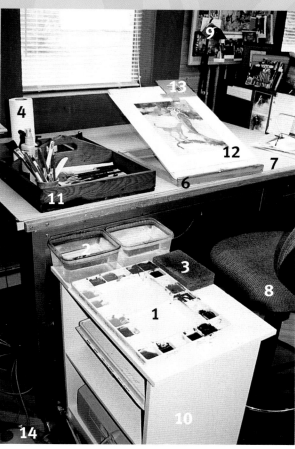

brushes, but you do need brushes that will hold up and keep a good point for painting figures. There are some great synthetic brushes that are less expensive and still perform well. I find I mostly rely on round brushes rather than flat ones because of their ability to carry a lot of water for large washes and yet come to a sharp point for detail work.

Paper

Paper is one of the most important items on the watercolor supply list. Paint behaves differently on different types of paper. Here are some basics to guide your choices:

- **Cold-pressed paper** has a fairly rough surface that facilitates painting beautiful ragged-edged strokes and smooth graded washes. It absorbs paint well and reflects light beautifully, so color stays bright. It is off-white, and it curls if not stretched.
- **Hot-pressed paper** is smoother than cold-pressed paper, but still has a slight tooth. The paint sits on the surface and can be pushed around longer and wiped out easier than it can on cold-pressed.
- **Synthetic paper** is very white and stays completely flat. You can wipe paint entirely off this surface, so paint can be reworked almost indefinitely. It does not absorb paint at all and feels like slick plastic.
- **Bristol board** has a very slick surface. Its greatest feature is that paint can be wiped out so the board is nearly back to white, so it allows for easy reworking.

My Favorite Paper

Paper is one of the most important considerations when it comes to selecting art supplies because its surface really affects how your paint will behave. I like 140-lb. (300gsm) hot-pressed Lanaquarelle. It's a great middle-of-the-road watercolor paper with a nice balance between absorbency for beautiful color and resistance to the paint for good lifting and reworking possibilities. If it is taped securely to a board, it will dry flat and not require stretching, so it saves time. It is also less expensive than 300-lb. (640gsm) paper. Ask your art supplier for recommendations.

Additional Supplies

- 4B and 6B pencils
- Bookshelves for art books
- Bulletin board
- Cabinet with partitions for storing paper and mat board upright
- Computer for digital photos
- File cabinet
- Hair dryer for fast drying
- Kneaded erasers
- Masking tape
- Painting apron
- Painting boards—Masonite and Gator board in various sizes
- Printer for printing out digital still pictures
- Small TV/video combo for watching art demonstrations on tape or DVD
- Stereo and favorite CDs
- Small slide viewer for painting from slides and reviewing slides of your own paintings
- Scissors
- Value scale

Maintaining a car kit

Now that you have your home setup together, let's take a look at what you need to carry in your car. If you really want to strengthen your watercolor skills, spend a little time painting outside or from a model every week. Even though I produce my best work painting in my studio—where there are no weather elements to contend with, no curious onlookers, no fleeting sun and no subjects in motion—the challenges of painting on-site are well worth the preparation.

In chapter six, you'll learn more about the benefits of painting from life. For now, here's what you need to carry to be ready to paint anywhere, anytime.

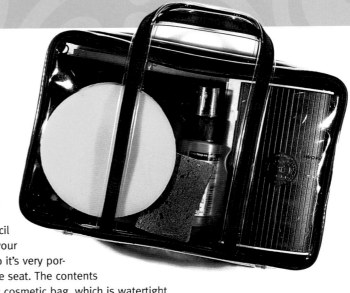

How to make your car kit

Your car kit should contain everything you need to pull over and do a quick on-site pencil or color sketch. Keep your kit small and simple so it's very portable and fits under the seat. The contents fit perfectly in a plastic cosmetic bag, which is watertight and has neat little pockets to help organize everything. The only thing that won't fit in the kit is a large bottle of water. You'll have to keep it separately in the car, and it's a good emergency item to have on hand anyway.

What to put in my kit

Small Winsor & Newton field box (professional-grade paint)

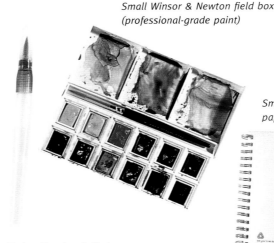

Small watercolor pad of 140-lb. paper (300gsm)

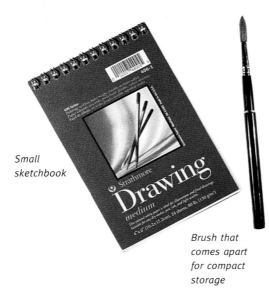

Small sketchbook

Brush that comes apart for compact storage

On-location brush that holds water in its handle and moistens the paint as you squeeze water into the bristles

6B pencil, sharpener and eraser

Collapsible water container

Small spray bottle

Folded paper towels

Using reference photos

Don't worry about the debate over using photographs to paint from. Whatever helps you create your best work is worth doing.

It takes almost as much creativity to get the right photo as it does to paint from it. Your photography ventures are the first stages of your paintings. A big part of the process is about being able to identify a subject that will make a good composition.

The most important thing is to use only those photographs you have taken. It is your reaction to the subject at the time you photographed it that's going to carry over into the painting.

Be sure to keep your reference photos organized so you can find what you want when you want it. Look for plastic photo sheets that hold six 4" × 6" (10cm × 15cm) photos to store your valuable refer-ences. Then sort them by subject in loose-leaf binders. Keeping binders is better than using photo storage boxes because binders are more portable and less bulky. You can store digital photographs on your computer or on disks, so you can enlarge and print them out as needed.

Create a labeling system for your binders
I label my binders by place or genre; for example, Figures, Architecture, Europe, and Local Landmarks.

Photo sheets
Plastic photo sheets make it easy to store your reference photographs in binders.

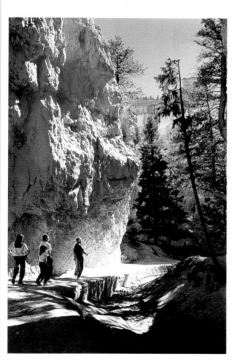

Reference photo of Navajo Loop
When a subject makes you catch your breath, don't let it get away without taking a photograph. I can still vividly remember the saturated color of the sandstone when the sun poured over these rock formations.

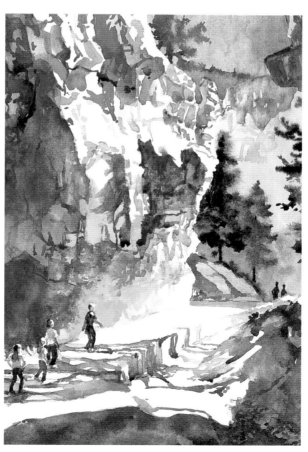

Transfer your excitement to paint
For me, the excitement I feel in capturing reference photos like this is almost as exciting as doing the painting later on. That's the purpose of the reference photo.

NAVAJO LOOP
14" × 11"
(36CM × 28CM)
COLLECTION KATHY
WARD, UTAH

Using a video camera for reference

You can also use a digital video camera to take pictures; then you can store them on your computer to paint from. There are some major advantages you get from a video camera that you don't get from a still camera:

- You can go frame by frame through the video and freeze the image in the exact lighting you want.
- You can take great shots at night or in very low light.
- The camera adjusts to the lighting and brightens the image when you are photographing dark shadows.
- You can photograph all views of the subject you want without using too much film.
- You can immediately view the image.
- There are no development costs and bad pictures to throw away.
- You can zoom in or crop the photo on the computer.
- The thumbnail format of storing the photos helps you see the design without the detail.
- Photos can either be printed out or enlarged to screen size to be painted right from the computer monitor.
- The images are less sharp, leading you to make more expressive paintings.

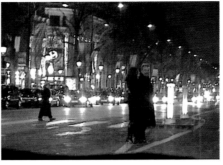

Video stills for reference
While the image stills from my video camera are not sharp at all; they provide all the information I need to create an expressive painting.

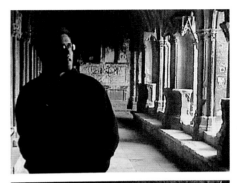

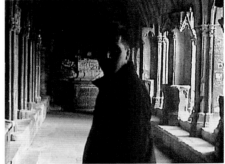

Use thumbnails to see design
The small format makes it easier to judge the strength of the designs because, with the details eliminated, you can focus on the values. The bottom thumbnail became the painting *Stranger in Arles* (page 30).

Different information leads to different paintings
I made this painting from a video still taken at night in Paris. If I had taken it on my 35mm camera, I likely would have missed all the figures in the background.

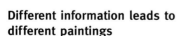

UNE PROMENADE DE NUIT
14" × 20" (36CM × 51CM)
COLLECTION OF ELAINE AND
HOWARD MITCHELL, CALIFORNIA

A painter's life

Chapter One Summary

- Keep painting even if your present studio situation is less than perfect.

- Having a private studio space will help you be a more productive artist.

- Always use professional-grade art supplies.

- Keep a simple kit in your car so that you're ready to paint at a moment's notice.

- It's all right to paint from photographs; just make sure you use your own.

Along with organizing our supplies, we need to organize our time to paint. It's so important to strike a balance between life and art.

Art is filled with spiritual analogies. Color reflects light, while black absorbs it—one is about giving back, and the other is about keeping everything for itself. Color has endless beauty and dimension, while black is dark and flat. If you take time from your art to give back to the important people in your life when they need you, your art will reflect a greater source of light that will add extra dimension and beauty to your paintings. I believe van Gogh was right when he said: "It is good to love many things, for therein lies true strength. Whosoever loves much performs much, and can accomplish much, and what is done in love is well done."

Reference photo for *Contemplating Fredericksburg*

There are some evenings or mornings when the sunlight drenches things in such rich, intense color that I can hardly contain myself emotionally. Such was the case as I captured my daughter enjoying the beautiful evening light in Fredericksburg, Virginia.

At times like this, I feel lucky to be an artist, because artists have learned to pay attention to these visual gifts of color and light and recognize they come from a higher creative source. Painting for me is a way to express my gratitude and deep admiration for the world that was created for us.

CONTEMPLATING FREDERICKSBURG
WATERCOLOR ON PAPER
11" × 14" (28CM × 36CM)

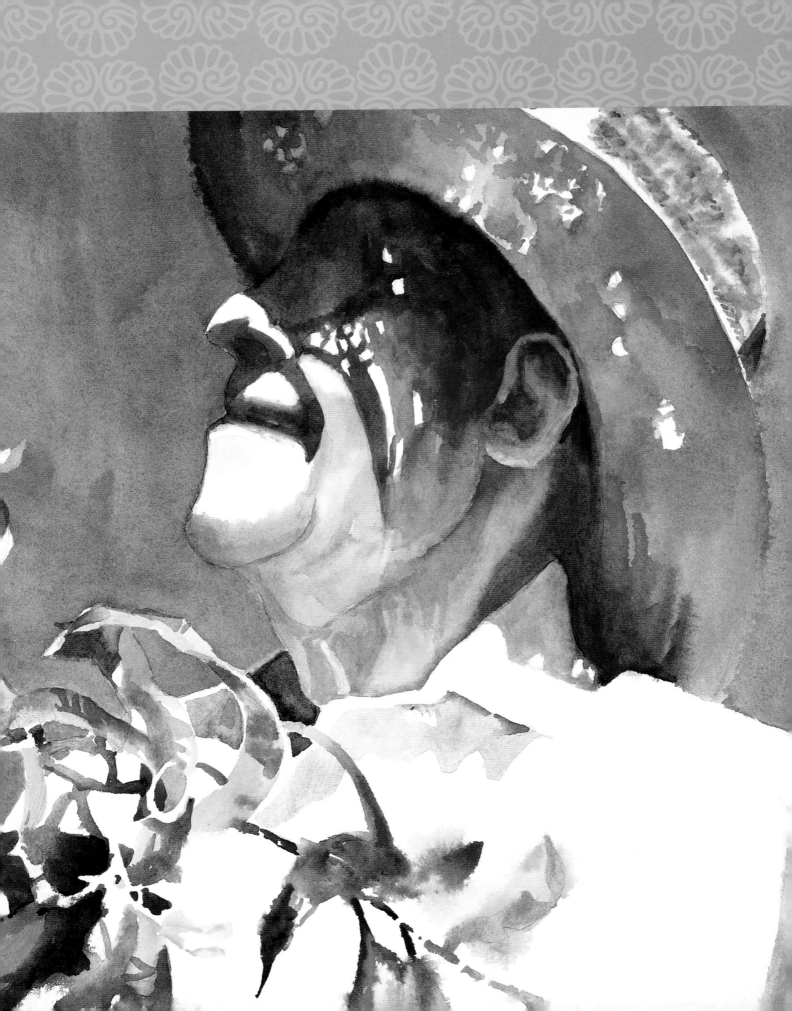

Simplify to Capture the Essence

It takes superior artistic talent to paint the impression as opposed to painting the reality—it is a rare ability to throw off the tyranny of detail and simplify a subject down to the essential emotional and atmospheric elements. The average artist merely struggles to simplify.

— DAVID DICKASON

There's an old saying, "You can't see the forest for the trees." It means we get too caught up in the details of a situation to see the whole problem. Consequently, we focus on things in an incomplete, piecemeal fashion, losing sight of the more important message of the big picture.

In painting a forest, we cannot begin by focusing on each individual tree; that would make the task much too difficult. Instead we have to simplify our work by combining the trees and treating the forest as a whole shape. This principle applies to painting people as well. If we do not begin by looking at our subject as a whole, complete unit, we will get lost in a forest of cumbersome detail.

This chapter deals with methods to help you simplify the figure. It is about unifying, reducing, and combining the shapes of your subject to help you eliminate detail and make it easier to render a figure that is believable to the eye. It is about painting an impression and boiling things down so that you can capture the essence of the subject. It may represent a whole new way of looking at things. You will learn to paint the impression and essence of your subjects, thereby rendering them more believable than ever before.

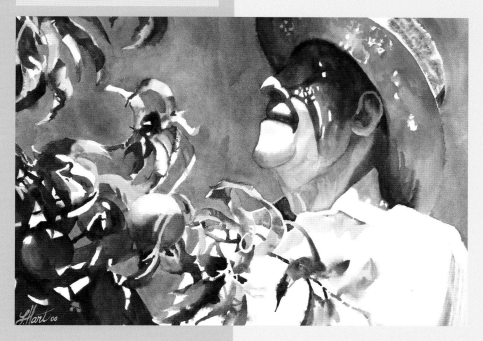

It's the dancing patterns of light that appear on the tree foliage and on my dad's face and hat that are important in this painting of my dad picking peaches. A detailed depiction of his facial features would merely have competed with that main idea.

THE FRUITS OF HIS LABOR
14" × 20" (36CM × 51CM)

Exercise

Figures are patterns of light and shadow

Suggestion can be more powerful than the completed statement. What you choose to leave out as you depict the subject is as important as what you choose to put in. Concentrate on bypassing detail early on; instead, paint the figure as a collection of abstract shapes of light and shadow. If you capture the overall essence of your subject before jumping to details, your work will hold together much better.

When you prepare to paint a figure, first mentally separate it into two abstract patterns of light and shadow. If this is a new concept for you, repeat this exercise until it becomes easy for you.

Place your subject with a strong light source coming from one side, not directly overhead, so you'll get a nicely balanced light-and-shadow pattern. You shouldn't have equal amounts of light and shadow; aim for a larger connected shadow area set off by smaller, broken light shapes.

Reference photo

1 2 3

Identify the patterns

1 Draw an outline of the figure. Then use even, diagonal strokes and a soft-lead pencil to shade in everything that is not in the light.

2 Trace the shape of the shadow area alone onto tracing paper laid over the first drawing.

3 Trace the shape of the light areas alone. It may seem a bit redundant, but it's helpful so your mind can see the light and shadow areas of the figure as two separate and distinct abstract patterns.

Follow the same process with watercolor

Following the same process in watercolor can create beautiful, simplified figures. Use one continuous wash of color for the shadow area. It will play beautifully against the stark white areas of the light shapes that are left as untouched paper.

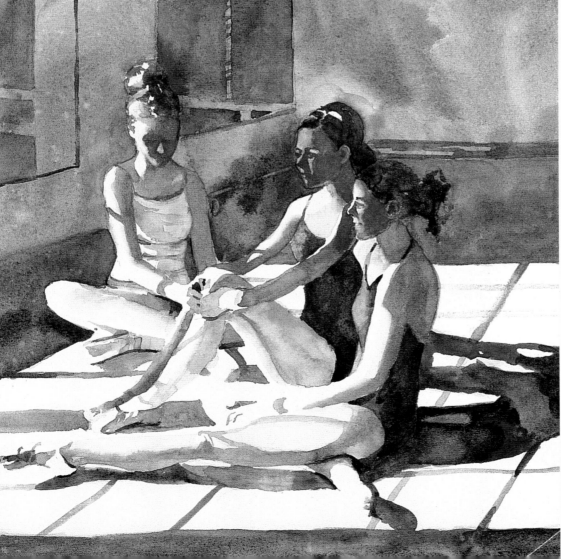

Connecting the shadow areas creates unity

This painting of my niece Kelsie and her friends relaxing after dance class is a good example of capturing the essence of the figures by focusing on the abstract light and shadow patterns. Notice how I connected all the shadow areas together to strengthen the unity of the whole pattern.

LIGHT CONVERSATION
11" × 14"
(28CM × 36CM)

Mass the shadow shapes to find the shadow pattern

Being able to see in masses, or linking shapes, is one of the most important skills to master as an artist. To mass things is to combine smaller objects or shapes together to form larger ones. It's like combining chores to make your work shorter and simpler. Massing helps you simplify because you see the subject as a whole interrelated shape. The purpose of combining shadow shapes is to help create a unified understructure that will hold a painting together. Falling into the trap of jumping to the details first is like a builder starting with the brickwork before laying the foundation of a building. It won't hold up.

1 Find a reference photo

Find a photo of a figure with sunlight coming from the side.

2 Block out detail

Lay a piece of tissue paper over the photo to help you see the dark value pattern.

3 Shade the massed shapes

Shade the shadow area, connecting it into a single large shape. You may have to cheat a little to make some connections where there really are none. You should be able to cut this mass out with scissors into a single shape. This is how you need to train your eye to see so that you'll be able to paint a first wash that will connect your painting.

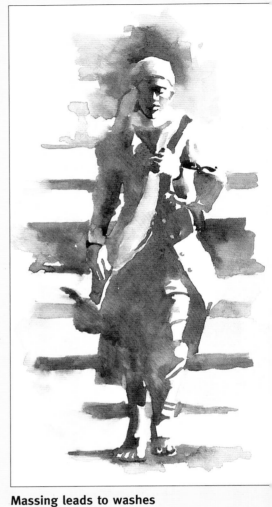

Massing leads to washes

The connected shadow shape holds the figure together and makes a smooth pathway for the eye to follow. Too many details become stopping places for the eye.

Use the shadow pattern to paint a good likeness

The shape of the shadow patterns as they curve over the contours of the head makes up the familiar configuration of a person's face. That's why it's possible to recognize people we know from a distance; we identify this shadow pattern before we identify their features.

Reference photo
Select a subject lit by a strong light source coming from the side.

Experiment 1
Draw the individual features of the face without any shading. You'll find it's far more difficult to draw using only lines. It's like trying to express an idea using a typewriter with only one working key.

Paint directly over the shadow study
When painting figures, it's useful to begin with a fairly complex drawing of the shadow patterns, and then apply the paint right over them. You can often leave the pencil marks in for texture as long as it's interesting to follow the clues they leave. If they bother you, though, erase them after the painting is dry.

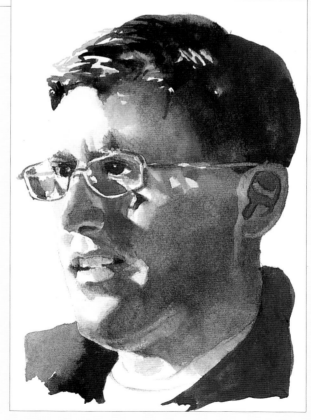

Experiment 2
Draw the face by copying the shape of the shadow pattern only and leaving out all linear detail. Compare your two drawings. It's surprising how little detail is needed to achieve an accurate likeness when you record form before linear detail.

Simplify: Use negative painting

Leaving some things "unsaid" is an important part of simplifying. It sets up an interaction with the viewer by allowing him to complete images in his own mind. Negative painting is essentially the technique of painting the space surrounding the main subject (positive space). I also like to refer to this as seeing in reverse or painting what isn't there. Many of my paintings employ this technique.

1 Mass the shadow patterns
Draw the figure in an outline form first, and shade all areas not in the sun.

2 Shade the negative space
Shade the the shape behind the figure without outlining it at all. This will be much trickier, but the results will surprise you. You have to think abstractly to leave most of the model as untouched paper. Compare your drawings.

3 Draw upside down
Now draw the figure turned upside down so your logical mind doesn't recognize what you're drawing. Turn your finished drawing right-side up and analyze it.

Reference photo
Select a subject in a strong light source coming from an angle.

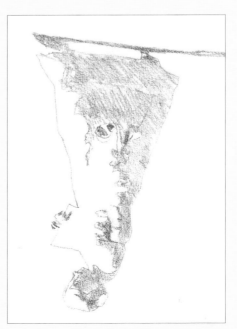

Add paint to capture the imagination
When you apply negative space concepts to paint, at first your eye sees a lovely abstract design, but eventually the figure of a woman taking a walk emerges. Sometimes the less you give away in your paintings, the more people will get from them.

Simplify: Use a strong light source against a dark background

Bright sunlight has a way of eating out detail where it hits people directly. I love to capitalize on this. Leaving these sunstruck areas as untouched white paper creates lovely abstract shapes that dance across the page and have the descriptive power to carry the subject with very little additional detail. The viewer's eye will subconsciously fill in the missing features. In order to set off these light patterns, a dark background is necessary.

Reference photo
I was drawn to this subject at the Norwegian Folk Museum because of the way the dark background set off the woman's face and the flowers in the bright sunshine. Without the dark shape behind them the white shapes would not "pop."

Mass the shadow areas
Shade all areas that are not in light. It's easy to draw the face because the features are simplified in the bright sun. Leaving most of the bush as a white shape indicates the presence of the blossoms; you don't have to draw each one. This kind of eliminating and combining will help your paintings say more with less.

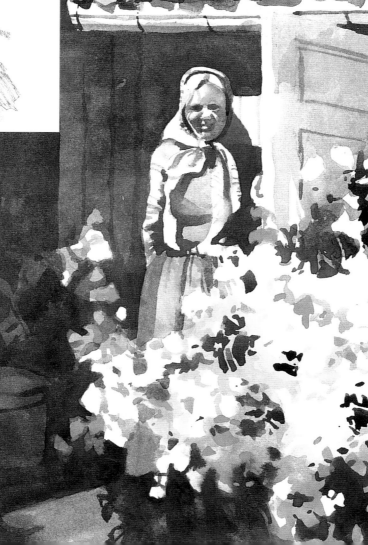

Watercolor results
Even though the sleeve of the woman's dress on the left side of the photo is blue, the contrast against the dark background makes it appear lighter; I have kept it nearly white. Make choices based on what's best for your painting's design rather than trying to stay true to the photograph. Here, I combined shapes and left out detail that would have fragmented the design.

Simplify: Backlighting helps unify your subject

Backlighting, in which the light source is placed behind the model, is also helpful in simplifying a subject by concealing form. When light comes from behind, subjects appear almost as flat silhouettes while remaining identifiable only through shape. It creates a beautiful connected pattern of darks where interior detail is so reduced within the figure that gesture alone is left to tell the story.

Rim lighting, in which only a sliver of light catches the edge of the face or clothing, is also a powerful tool to help depict characteristics in a very abbreviated yet somehow extremely expressive manner. With this type of lighting, almost all detail is sacrificed to show off the highlights, which are what I want the viewer's eye to notice first.

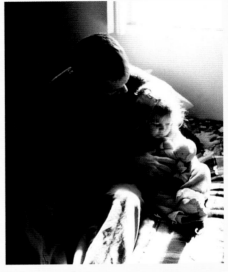

Reference photo
In this moody scene of my son and grand-daughter, the light is coming through the window behind them. You can see what a dramatic image this creates—a dark silhouette surrounded by a bright halo of light. The interior detail in the figures is almost completely swallowed up in their combined dark shape.

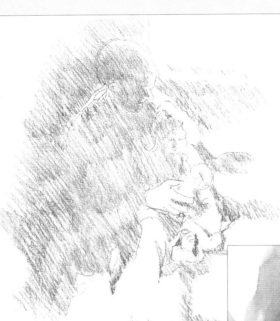

Mass the shadow pattern
Draw the image by shading the shapes of everything not in light. Notice how minimized the light pattern is on the figures' faces. Does it surprise you how much emotion can be conveyed through such minimal information?

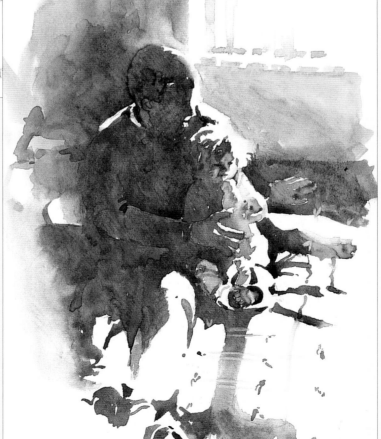

Watercolor results
Lighten a dark shape like this considerably, while keeping it connected and flowing in and out of the background and figures. The elimination of interior details provides unparalleled continuity, unity and emotional impact.

9 Ways to soften and lose edges

Hard edges create stopping points for the eye. That's why they're best used at the focal area, where you want the eye to stop. Leaving every edge hard in a painting, though, calls for the eye to look nowhere and everywhere all at once. Too many hard edges in a painting give it a tight, harsh, confined look, so the painting won't read true, because eyes don't see everything in sharp focus at once.

Opening or softening some of those exterior edges allows the eye to move in and out of the background. Losing edges is a way to open up shapes to create a pathway for the eye to move smoothly through the painting. This keeps your figures from looking cut and pasted. By letting some of the figures' inner details merge, you avoid a fractured or splintered look within them and create a wonderful, loose, wet quality—exactly what we strive for in watercolor.

The magic 9
Practice each of these methods until you feel confident losing edges. Mastering the methods of losing and softening edges will take you a long way toward your painting-people goals!

1 *Allow two wet edges to bleed into each other.*

2 *Place two similar values next to one another.*

3 *While paint is wet, soften an edge with a clean, damp brush, and blot with a paper towel.*

4 *When paint has dried, soften an edge with a clean, damp brush, and blot with a paper towel. This leaves a bit more of a residue than softening edges when paint is wet.*

5 *Create a soft halo effect by painting clear water around a dry shape and then painting up to the wet edge, allowing the paint to bleed into the wet area. This is a nice effect for hair in sunlight.*

6 *Pull paint through the image into the background, and wash away the outer edge with clean water.*

7 *Paint on damp paper, and allow the edges to bleed outward.*

8 *Soften outer and interior edges of a subject by glazing a very pale wash over the entire area after it is dry. Use a very soft brush and a gentle stroke, or the paint can lift too much.*

9 *Pull a soft-edged image from dry paint with a damp brush, and blot with a paper towel.*

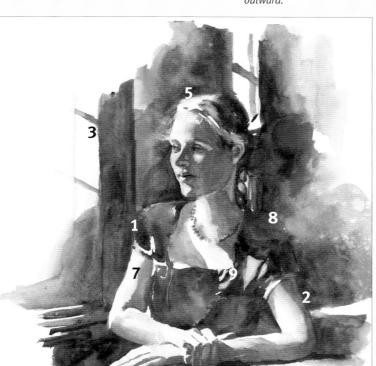

The methods applied
In this watercolor study, I have applied most of the techniques for producing soft and lost edges. Losing edges and painting through the model will help simplify your paintings by creating a smooth pathway for the eye to follow.

27

Use an underpainting to tie your subject to the background

Another important way to simplify involves unifying the subject and background by initially connecting them with an underpainting. This helps tie the entire picture together before breaking it into parts.

An *underpainting* is a light wash that covers the whole paper except for the white areas. It helps to integrate the subject with the background so it doesn't look like they belong to two different paintings. The underpainting also simplifies the work by covering the majority of the page in one quick step.

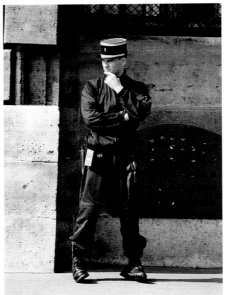

Reference photo

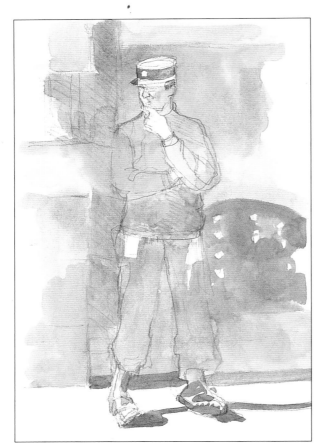

Make the figure part of the background
For a successful underpainting, your first wash over the entire area should treat the figure as if it were transparent. In this way the figure is simply part of the background. Leave only those areas in strong light untouched.

Use the underpainting to define the painting
After the first wash dries, you can define much of the figure by painting around it, leaving a different kind of edge that avoids a cutout look. You can create light patterns by simply letting the underpainting show through to further unite the figure with the background.

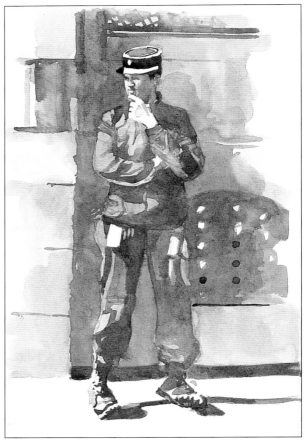

You can best show truth by painting an illusion

Chapter Two Summary

- Leaving some things unsaid in your paintings will add life and excitement.

- Get the overall pattern down before jumping to the parts.

- Look for the abstract patterns of light and shadow.

- Mass shapes to strengthen and unify your paintings.

- Eliminate detail where bright light hits the subject.

Over the years I have discovered an interesting paradox in painting: The more abstractly or without detail you paint something, the more realistic it will appear to the eye from a short distance. I think the reason for this is that the eye merely records abstract shapes of light and shadow, while the brain takes that information and processes it into recognizable things. So if we paint the abstract patterns just as the eye sees them, the viewer's brain will translate them into realistic objects. I know it's a mind twister, but it's true!

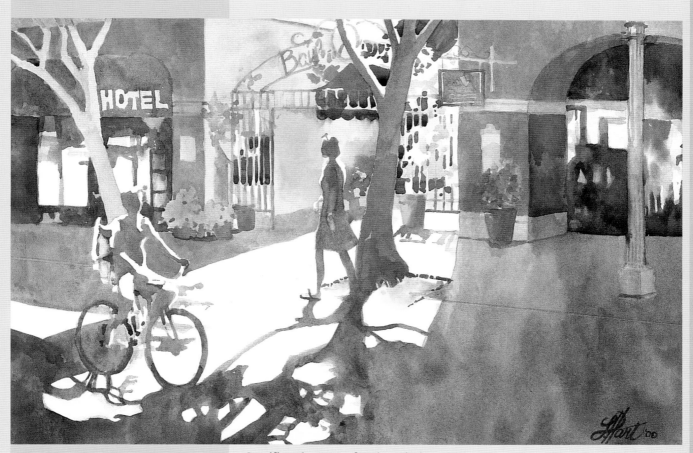

Sacrifice the parts for the whole

In this painting of a favorite place of mine in California, I connected the shadow shapes into one mass to give an overall sense of unity. Notice how the female figure and the bicycle melt into the shadow patterns and become part of the overall design. Because there are few hard-edged breaks in this wash, the eye can move smoothly through the painting, which is why it holds together well. I think this is a classic example of the importance of the parts being sacrificed for the sake of the whole.

BALBOA INN
14" × 20" (36CM × 51CM)

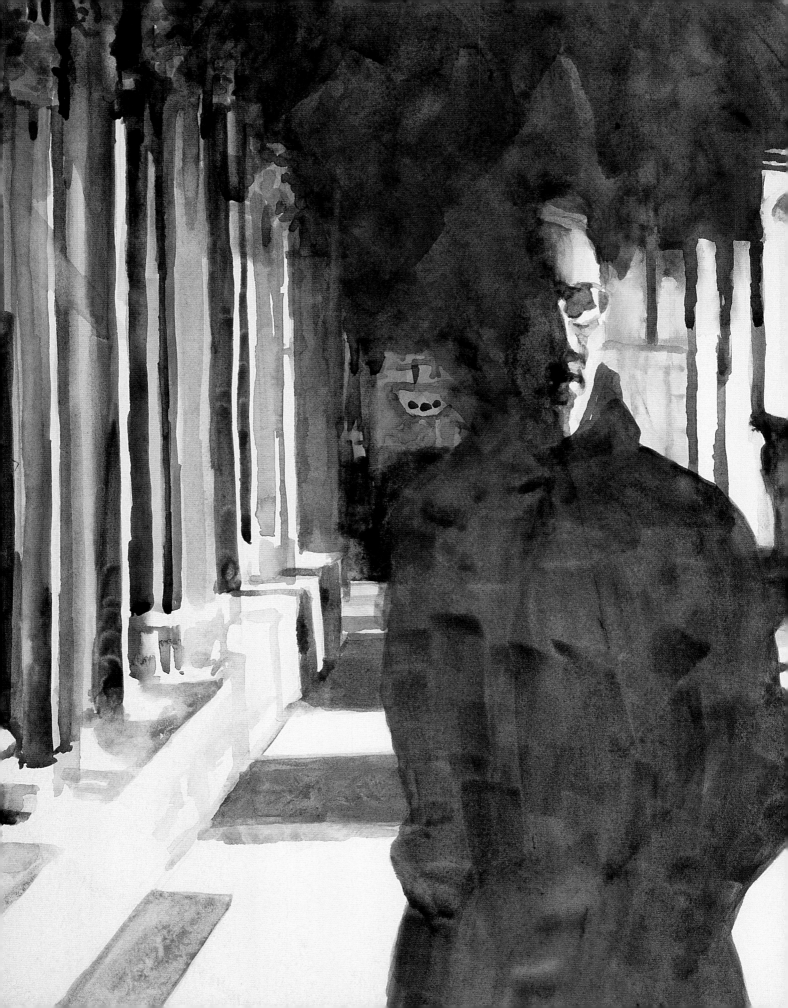

Designing Strong Paintings

The whole arrangement of my picture is expressive. The place occupied by the figures or objects, the empty space around them, the proportions—everything plays a part.

—HENRI MATISSE

When my sons were in high school, they inherited our dilapidated old family car, which they and their friends lovingly dubbed "the Buck" since the *i* had fallen off the Buick nameplate. At one point they painted a bright red stripe and a number on the front in an attempt to disguise it as a race car, but that didn't make it any faster. The Buick remained notorious for breaking down. Due to the frustration it caused them, they finally let the car rust in peace and gave it this fitting epitaph: "The Buck stops here ... there ... and everywhere."

Design is the vehicle that delivers the message for us as artists. "The buck stops here" can also be said for design because no matter how you try to decorate or disguise a poor composition, the painting will still break down—here, there and everywhere.

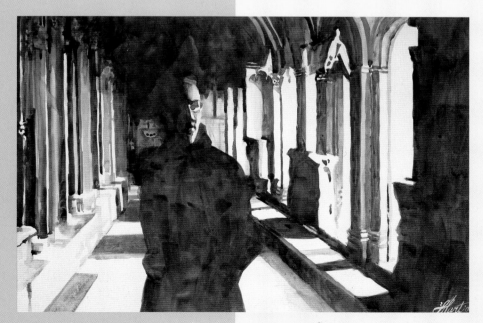

This painting's design helps create a sense of mystery surrounding the French character. The strong darks out of which the figure seems to emerge heighten the intrigue even from across the room.

This painting was included in the 8oth Annual Exhibition of the National Watercolor Society.

STRANGER IN ARLES
WATERCOLOR ON PAPER
14" × 20" (36CM × 51CM)

Design is the overall arrangement or layout of the subject matter within the parameters of the paper. It is an underlying skeletal structure devised by the artist to hold a painting together and show off the subject in an appealing way. Even though you may have something great to say in a painting, if you have a weak delivery, no one will listen. Settling for poor design is like giving a speech in an auditorium without using a sound system to amplify your words. Good design can shout your message across a room. If a painting is not visually dynamic, it will fail, plain and simple. Once you let the subject take a backseat to the overall design, your work will become stronger, and your message come through louder.

Composition literally means "with position." When we talk about a strong composition, we're talking about the entirety of the painting's contents. We're referring to the compelling placement of the light and dark shapes. A composition is dynamic if you can easily discern the patterns of lights and darks from across the room. A wise teacher taught me to spend 95 percent of the time on painting elements that can be seen from thirty feet away, because that's all that matters in the end. In other words, the composition is often more important than the subject.

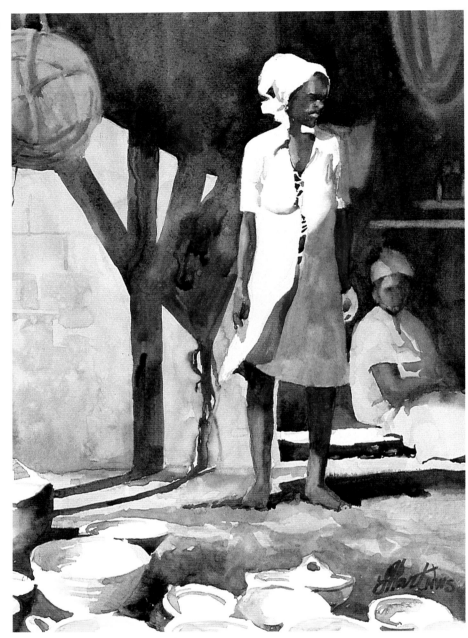

Design delivers your message

This painting achieves its strong design through the placement of the subject—the woman in white—against the dark, abstract shadow shape. The quiet strength and resolve of the main figure is set off by and echoed in the strong verticals of the dark shadow behind her. In this way, the design portrays her strength of character even better than a detailed facial expression could.

AFRICAN MARKETPLACE
14" × 11" (36CM × 28CM)

Seeing good design and composition

So how do you identify a strong composition? Strip out details. This involves that "thirty-feet-away guideline" from the previous page. There are a couple of ways to do this.

Viewing thumbnail photos

The small format of thumbnail photos acts much the same way as a painting viewed from a distance. It reduces images to lights and darks so you see the value pattern without interference from the details. Looking at thumbnail photos on a computer browser can provide good design practice for your eye. Notice which ones make you do a double take, and ask yourself why. Most often, it will be because of dramatic contrasts between lights and darks. Collect good designs cut from art magazines and newspapers, and display them so you can refer to them often.

Back away or use a reducing glass

Backing away from a painting frequently as you work on it is good practice, to avoid losing sight of the whole picture. If you have a small work space, however, backing away may not be possible—as was the case with my old "closet" studio space. If you have limited space, try a reducing glass. A reducing glass looks just like a magnifying glass but does just the opposite job; it reduces the image to a very small format, enabling your eye to see the design as if you were looking at the image from a distance.

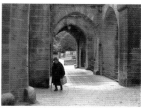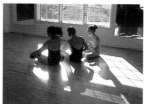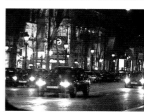

Thumbnail photo exercise
Study these thumbnail photos. Which ones are compelling designs? What makes some designs jump out more than others? If you will spend a little time in this thinking exercise, I promise it will strengthen your ability to design better paintings of your own.

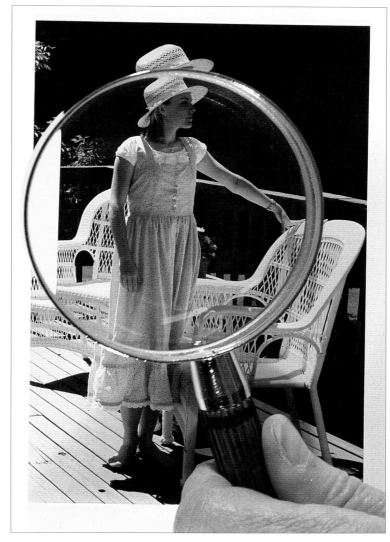

Reducing glass
The farther from the photo or painting you hold the reducing glass, the smaller the image will appear.

The format is the placement of the subject within the paper's borders. Choosing the format is similar to looking through a camera's viewfinder: The goal is to place the subject on the paper in an aesthetically pleasing way. How do you know if a placement is aesthetically pleasing? There are "rules" we could talk about, but I prefer a more intuitive approach. If it feels good to you, go with it. Trust your own judgment. Place the subject on the paper where it has the most impact—usually not dead center.

You can make a painting very powerful by pushing the subject far to one side or zooming in extra close. When you zoom in you also cut down on the negative space, or the areas that surround the subject. Many paintings look "marooned" because the subject seems to be a deserted island floating in too much empty space. Anchor your subjects in the format by tying into the sides. Let your subjects fill the space and run off the page in places.

An easy and practical way to develop a strong design is to format your photos before you begin painting. Viewfinders can help with this.

Once you've had a little viewfinder practice, good formats will immediately jump off the page at you. Try this on reference photos. I often tape the viewfinder directly onto my photo when I find the format that pleases me most.

Using a homemade viewfinder

Cut a small mat board into two L shapes, and place them together so they form a frame around a figure. Move the L shapes around, expanding and contracting the opening until you see a good breakup of negative space behind the figure with small, medium and large areas around the subject. Try several different configurations, even zooming in so close that it gets cropped off by the borders of the window. Try one where the subject gets pushed far to one side. Try it in a vertical format, and then a horizontal format.

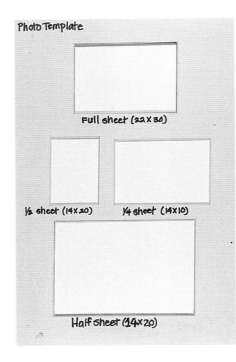

Photo Template

Full sheet (22 x 30)

½ sheet (14 x 20) ¼ sheet (14 x 10)

Half sheet (14 x 20)

Using a precut window viewfinder

I learned this trick from Joan Rothel in her article "Zeroing In on Good Subjects" (*Watercolor Magic*, March 2003). First, cut small windows in a mat board that are the same proportions as a quarter, half and whole sheet of watercolor paper. Then, according to the size painting you plan to make, choose the corresponding rectangle to place over your photo to format it. You can tape your photo directly to the back of the viewfinder for reference. I often use these stencils to trace rectangles in my sketchbook for my value sketches so they will also be properly proportioned.

5 classic compositions to sell your subject

If you want a more structured way to choose design, consider a standard design structure. These have been used and proven for many years as successful understructures. When we place original subject matter on top of them, we can maintain a fresh, exciting look to our work.

There are many tried-and-true design formulas artists have used for centuries, but I will present only five of my favorites here. However, it would be of value for you to study formal design in more depth and learn what design structures appeal to you. They might be useful as you begin to build your paintings. Look for *The Artist's Design: Probing the Hidden Order*, by Marie MacDonnell Roberts (Fradema Press, 1993), and *The Painter's Workshop: Creative Composition & Design*, by Pat Dews (North Light Books, 2003).

The cruciform

This design obviously gets its name from the configuration of a cross it makes on the page. The subject matter is arranged as a dominant vertical shape intersecting a less prominent horizontal shape, or vice versa, pretty much at right angles. These crossing bands should ideally run off the page at some point on all four sides to anchor the subject securely in the rectangle. Sometimes the subject matter itself will naturally dictate using this type of design, such as the strong horizontal bands of mountains and sky in a landscape being intersected vertically by a close-up tree or figure.

Diagram of cruciform, or cross, composition

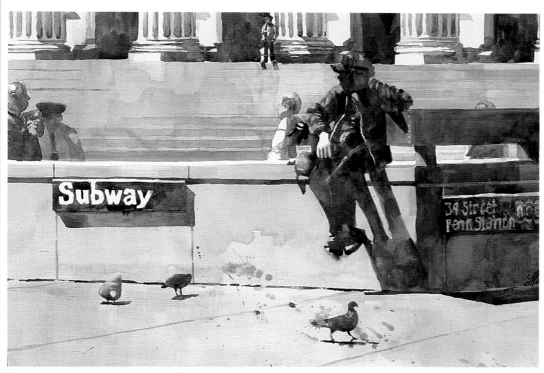

Cruciform structure in action
Here the main figure and his shadow compose a strong vertical shape that intersects the less important horizontal bands created by the wall he's sitting on and the steps. Notice how the pigeon directly under the figure serves to visually continue the strong vertical shape to the bottom of the page.

ON GUARD
14" × 20"
(36CM × 51CM)

S or Z composition

The main element of this composition is a zigzag or snaking design made either by the subject itself or the negative space which surrounds or goes through it. The S or Z shapes themselves are often light or dark in value; that is what first grabs the viewer's eye and leads it into the painting from the bottom to the top. This composition is often used in landscapes in which the artist uses a river or road to create a pathway into the painting.

Diagram of an S or Z composition

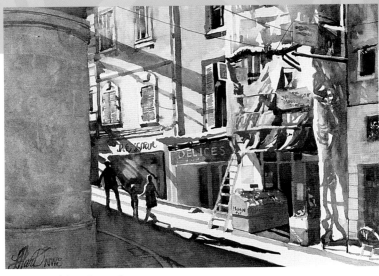

Z composition in action
In this example of a street scene in France, the shadows on the building and the lighted patch of pavement create the Z pattern that draws the viewer's eye into the bottom of the page and continues directing it back and forth to the top. It is important in this composition to create visual stops at the sides of the picture plane to keep the eye from running off the page at the places where the Z takes it near the edges.

NARROW STREET IN FRANCE
14" × 11" (36CM × 28CM)

Pyramid composition

This simple composition is based on the subject matter being arranged in a triangular shape and resting on a strong horizontal base that anchors it to the lower portion of the picture. This base can be a solid or broken shape that serves to support the subject matter.

Diagram of a pyramid composition

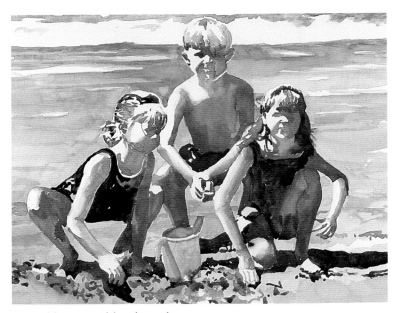

Pyramid composition in action
In this painting, the three figures form the pyramid shape and their shadows and the churned-up sand provide the base that anchors them to the bottom of the painting, even though it is a broken shape.

BEACH BUDDIES
11" × 14" (28CM × 36CM)

Division-of-space composition

One of my favorite composition schemes is called a division-of-space composition. It is characterized by relatively straight spatial separations that break up the background into a skeletal grid on which the subject matter is hung. The main image should encroach onto more than one of the rectangular shapes behind it to tie it to the background.

I particularly like to use this for painting people because the rigid straight-edged shapes of the background serve as a nice foil to the more organic and fluid lines of the human form.

Diagram of division-of-space composition

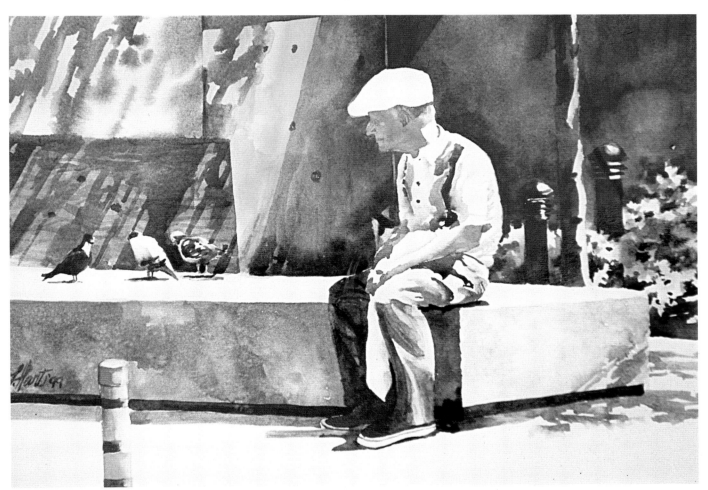

Division of space in action
The rectangular shapes of the bench, the sheets of plywood and the dark shadow on the right create geometric space divisions within this painting that set off the figure's rounder shapes by contrast. The breakup of space in the background adds variety and interest to an otherwise boring expanse of space in which the figure would seem isolated. This offers the figure a framework on which to hang.

PIGEON WATCHER
11" × 14" (28CM × 36CM)
COLLECTION KELLY HANSEN, UTAH

Path-of-light composition

In this composition the pattern of light shapes is used to help lead the eye through the painting, creating movement and direction. A captivating composition is one that entices the viewer to keep looking around inside the painting. It's your job to provide a visual pathway that leads to your focal point or the main idea of your story. This concept is much like the S or Z composition, but the visual pathway may be broken up more like stepping stones rather than a continuous roadway, and it often follows a circular motion. Light is one of the most effective tools you can use to help you construct a good painting; it is by far the one I rely on most often.

Diagram of path-of-light composition

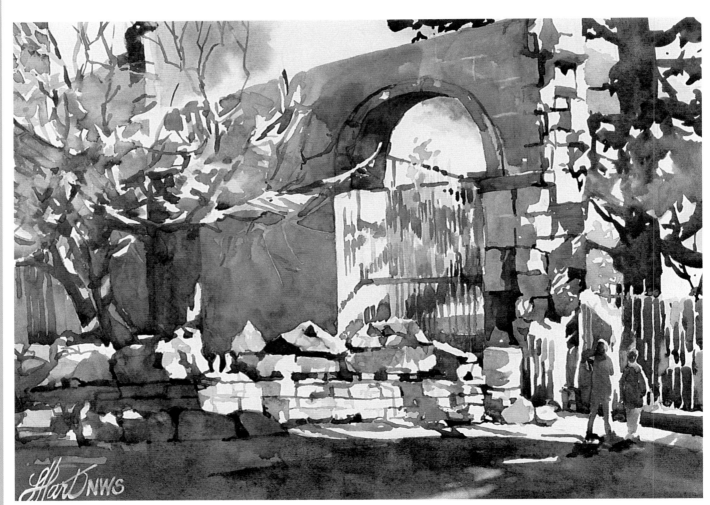

Path-of-light composition in action
The white shapes of light serve as a lead-in to this painting, inviting the viewer to step in and take a walk around. The eye follows these white shapes up into the rocks and then around in a circular motion throughout the rest of the painting.

ROMAN RUINS, ARLES
11" × 14" (28CM × 36CM)

The focal point, or center of interest

Creating a strong *focal point* (also known as the center of interest) will help showcase what you are trying to say about a subject by directing the viewer's attention to what you want them to see first. Focal points don't just happen, they have to be intentionally set up. Think of the way products are displayed at the grocery store to grab your attention; they're often placed right at the front of the store, usually at eye level, accented with bright colored flags or signs, and sometimes even accompanied by a person waving you down to sample something. Some of these same marketing tricks also apply to painting. You have to carefully calculate the best way to make the viewer take notice of your message.

Using contrasts

The most effective way to establish a strong center of interest is through the use of contrasts. The more contrast, the more the eye will be drawn to the area. Following is a list of contrasts that, when placed at the center of interest, will add a great deal of punch to your paintings:

- Lightest light against darkest dark
- Coolest color against warmest color
- Busy area against restful area
- Dimensional space against flat space
- Brightest color against neutral gray
- Hard edge against diffused edge
- Detailed area against abstract area
- Largest shape against smallest shape

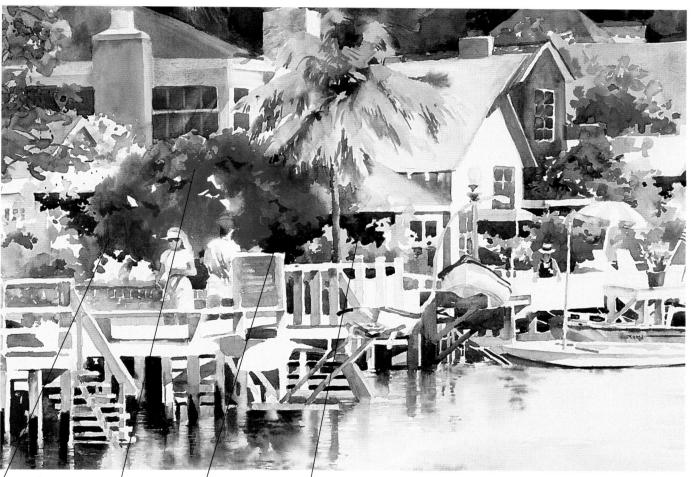

The bush in one of the four "sweet spots." (See page 40.)

Brightest color against neutral area.

The darkest value behind the brightest and lightest colors makes them stand out.

Hard edges and sharper detail capture attention.

A strong center of interest directs the eye

Contrast is one of the major tools you have to highlight the focal point. In this painting, I have employed some simple sales techniques to direct the viewers attention to what I wanted them to see first: the beautiful bougainvillea bush.

GRAND CANAL
14" × 20" (36CM × 51CM)
COLLECTION OF HAROLD AND JULEE
BUFFINGTON, UTAH

Where to put the focal point

Referring back to the analogy of the grocery store, *where* the product is placed has much to do with how successfully it will sell. It's like the saying in real estate that the three top reasons properties sell are location, location and location. The same is true of art; there are certain spots in the rectangle that are most appealing to the eye.

The main thing to remember is that it is better aesthetically not to position objects in the center of a rectangle but instead to place them to one side, roughly about one-third of the way across. An easy way to accomplish this is to use the *rule of thirds*. Use parallel lines to divide the picture into thirds both horizontally and vertically. The four points at which these lines intersect each other in the rectangle mark the four "sweet spots"—the most appealing areas to place your center of interest.

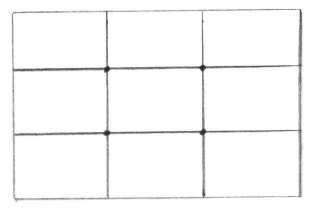

The four sweet spots
This illustration shows how simple it is to find the sweet spots in any painting. Just divide the picture into thirds horizontally and vertically, and use the cross points as guides to place your focal point.

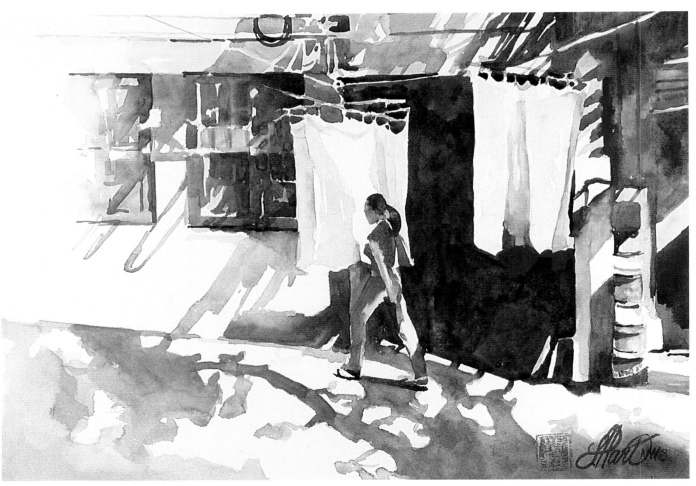

A well-placed focal point
In this painting, the focal point—the laundry hanging in the doorway—is in the upper-right sweet spot. This is the place where the darkest dark sets off the lightest light, as well as the point where the sharpest edges and the busiest light shapes have been intentionally placed to draw attention.

CHINESE LAUNDRY II
11" × 14" (28CM × 36CM)

Putting it all together

The goal is to use all the elements we've discussed to create the best possible compositions for your paintings. Your viewfinder can help you choose how to crop your photo in different ways to position the focal point in just the right sweet spot. Using these tools, you'll be able to create several different workable compositions. After that, it's up to you to decide which composition moves you the most.

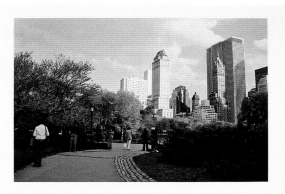

Where is your focal point?

Once you choose a photo, decide which area of the photo you want to emphasize. In this photo, I wanted to showcase the area in which the foliage is brightest in front of the buildings in sunlight. Since that area is right in the center, I experimented by moving it into each of the four sweet spots with the help of my viewfinder.

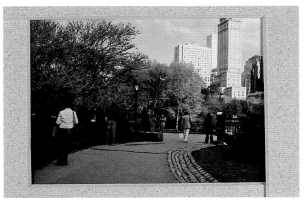

Upper-right sweet spot
Placing the focal point in the upper-right sweet spot gives the eye a nice pathway by making much of the walkway visible.

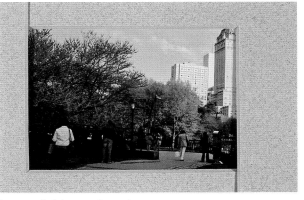

Lower-right sweet spot
Placing the bright foliage in the lower-right section makes the figures in the focal area a little more prominent, which I like.

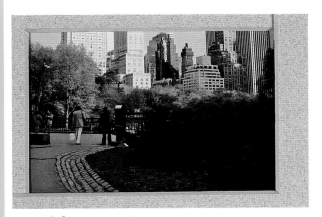

Upper-left sweet spot
Placing the focal point in the upper-left sweet spot meant sacrificing the pretty violet of the foreground tree and cutting off much of the walkway.

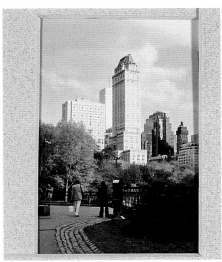

Lower-left sweet spot
The vertical composition doesn't work for me because the tall building is now dead center, which makes for a boring painting.

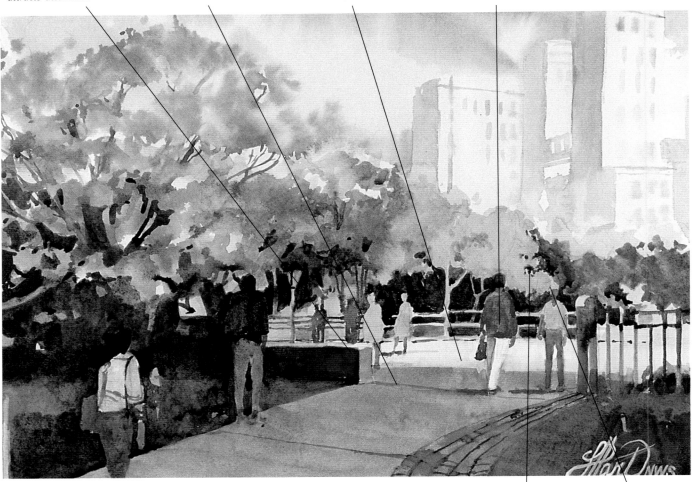

Sharp edge in this area attracts attention.

A midvalue shadow over the foreground further emphasizes the trees and buildings in the sunlit area.

The vertical and horizontal pathways converge at the focal point.

A person in a bright color in this area helps to attract the eye by adding human interest.

Dark value next to it makes it stand out more in contrast.

Brightest color on the foliage.

Make your choice, and create your painting

This is the painting that resulted from my focal-point positioning exercise. I chose to place the focal point in the bottom-right section because it brought the figures a little closer (making them larger), and it shows more of the light walkway, leading the eye directly to the focal area. I also like how the figure in the lower-left corner serves as an arrow pointing up into the painting.

CENTRAL PARK SUNSET
11" × 14" (28CM × 36CM)

Caveat

I have presented a lot of rules about design in this chapter, but remember that your art comes from you and your thought processes, not from a system of hard-and-fast rules. Art is about trying things. You have to make judgments based on intuition and gut feelings. Don't be afraid to go against the rules in your painting if you have good reason to do so—that's often how great paintings come about.

Thoughts on finding your own voice

Chapter Three Summary

- Design is an underlying structure devised by the artist to hold a painting together.

- Composition is the overall content and placement of shapes and values within the picture plane.

- The majority of painting time should be spent on that which can be seen from thirty feet away—not on the detail.

- A dynamic composition has light and dark patterns that are easily discernable from across the room.

- Back away from your painting often so you do not lose sight of the whole picture.

- We can place original subject matter on traditional design structures and still create fresh work.

- Strong focal points have to be intentionally planned.

- The best way to establish a focal point is through contrasts.

So now we know that design will help you get your message across, but what is your message in the first place, and how do you find it? We hear so often how important it is to have good content in our paintings, but how do you define something so subjective?

Finding your own voice has to do with painting your feelings for a subject rather than a precise likeness of it. Until that happens, painting will merely be an academic exercise. Artists need to paint what they have emotional feelings for and not what someone else wants them to paint.

Good, expressive art addresses a universal emotion through an individual viewpoint. Art that relies on sentimentality or nostalgia will not hold the viewer long. Below are some things to think about as you paint to ensure that your art has valuable content.

- Look for subjects that reflect who you are and what you love.
- Reach for intrigue, mystery and ambiguity.
- Treat subjects that evoke reverence or adoration within you.
- Reach inside yourself to capture your emotions at that very moment.
- Take risks, and stretch your imagination.
- Portray your personal vision of the subject, not a photorealistic copy of it.

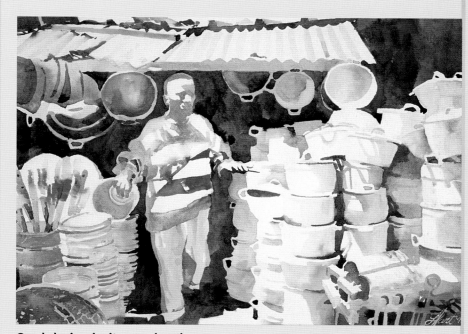

Good design invites exploration
The repeated pattern of light circular shapes leads the viewer through the painting in a counterclockwise path. The eye enters the painting at the bottom edge and follows upward along the lighted side of the stack of pots until it comes to the row of hanging pots on the roof. At this point the track of vision gets pulled to the left side and directed down again by the row of pot handles pointing downward, moves into the figure and starts around again. A circular track of vision like this in a painting will invite the viewer to keep exploring it over and over.

AFRICAN SHOPKEEPER
11" × 14" (28CM × 36 CM)

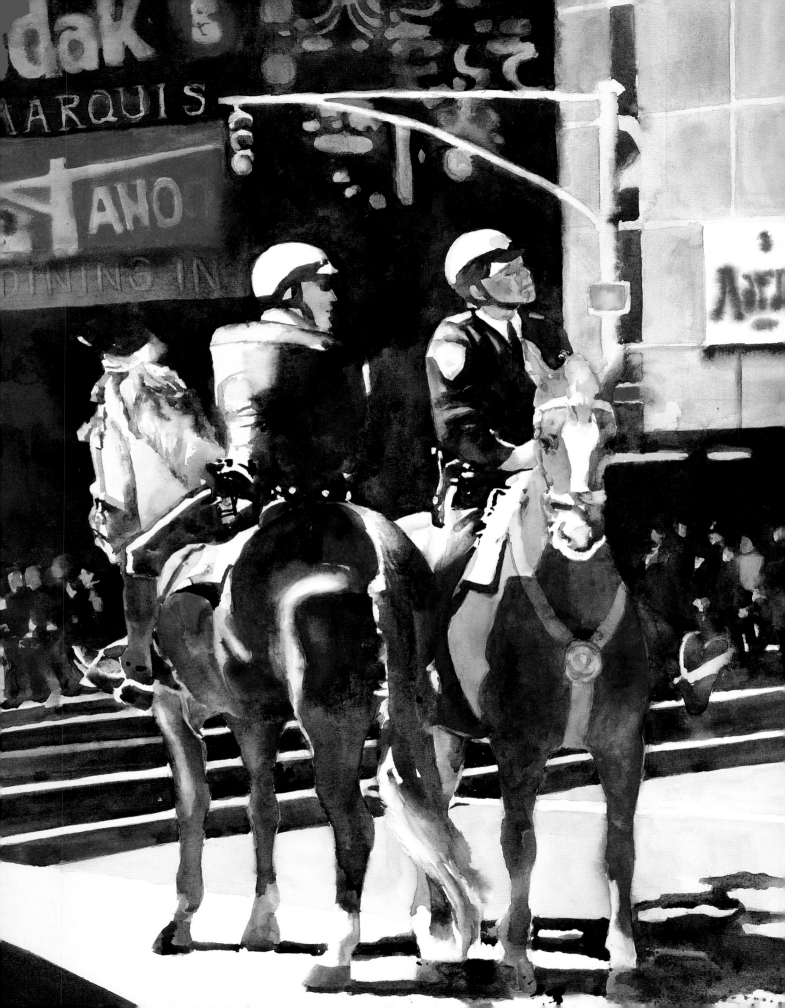

CHAPTER FOUR

Value: 10 Ways to Get It Right

No qualities or texture can save a painting that has ... unreadable values.

— FRANK WEBB

Historians tell us that one of the main reasons for the fall of the Roman Empire was the abandonment of its own established value system. This corruption eventually led to the collapse of the empire from within. Sticking to the value system could have prevented this downfall. The term *value* in art refers to light and dark tones, something quite different than moral values yet with similar impact. Just as a civilization can be ruined by not upholding its values, our paintings will self-destruct if we don't establish a clear-cut value plan and stick with it to the end of the painting.

Identifying values correctly is another key skill you need to create successful paintings. Value is simply how light or dark something is in relation to a graded tonal scale. It is value, not color, that is critical to get right. You can paint with arbitrary color and still turn out a painting that works, but you can't paint with incorrect values and still have a painting read accurately. There are many black-and-white pencil and charcoal renderings that stand as proof that color is not even an essential element in art.

This chapter presents ten practical ways to help you clearly see and establish correct values in your paintings and give you the ability to create stronger, more enduring work. You will learn to train yourself to become proficient at identifying values correctly and transferring them into color accurately.

Value contrast creates drama
In this painting, the dark values set the backdrop for the sunstruck figures in front. The mounted policemen would not show up nearly as dramatically if they were not played against a dark value.

BIG BREAK ON BROADWAY
20" × 14" (51CM × 36CM)

Use a ten-degree value scale

The value scale is an artist's best friend. Use it as a constant companion to keep you from painting incorrect values. The ten-degree value scale should range from white paper (1) to black (10). With this great little tool, you need never paint an inaccurate value again.

Accurately calculate shadow values

One important advantage to working with a ten-degree value scale is presented by Jan Kunz in her book, *Painting Watercolor Portraits That Glow* (North Light Books, 1998). She maintains that on an object in sunlight, the shadow side will be 40 percent darker than the side in sunlight. With a value scale made up of ten degrees, each degree equals 10 percent of the whole scale. Thus you can determine exactly how much darker 40 percent is on a ten-degree scale. For example, if you painted the light side of a face as a value 2, then 40 percent darker would be exactly four degrees darker on the value scale, or value 6. This is a very practical formula to rely on when painting shadows on figures.

The only variances I have found are that the shadow side of subjects in artificial lighting may be even darker than 40 percent and that there may be no shadow side at all if there is more than one light source.

The ten-degree value scale
Value scales can be found in most art supply stores. In spite of the fact that I had to renumber the values to reflect the order I use (1 being the lightest and 10 being the darkest), this is the one I like best. Having the lights on one side and the darks on the other is helpful for creating a painting in two basic washes, which is why I labeled the light side with "wash 1" and the dark side with "wash 2." (You'll learn more about the two washes in chapter five.) The holes at the edges allow you to hold it up to your photo or subject and look through them to match the values. If you squint through the value hole and the subject behind blends perfectly, you've matched the value.

Figures in sunlight
The light side of the faces is almost a value 1, so the shadow side by nature will be 40 percent darker, or value 5.

Materials

PAPER
Any watercolor paper

BRUSHES
No. 8 round

PIGMENTS
Aureolin, Cadmium Red Medium, Manganese Blue, Ultramarine Blue, Yellow Ochre

OTHER
6B pencil
Kneaded eraser

Let's practice painting the shadow side four degrees darker than the light side to approximate natural sunlight.

Simple practice
Start out on the simple form of an apple.

1 Paint the light side
Draw an outline of an apple in sunlight. Using a no. 8 round, paint the shape with a light wash of Aureolin. When dry, check the value with your value scale. This is a value 3.

2 Paint the shadow side
Four degrees darker than the light side makes this a value 7. Mix some Manganese Blue with your Aurolin puddle.

Paint a small practice swatch, and let it dry. Test it with your value scale to be sure it's dark enough. If not, add more blue. If it's too dark, add more water.

Now paint the shadow side. The cast shadow is even darker, so add Ultramarine Blue to the mix for that.

Applying the rule to figures
Using a simple wooden manikin, let's see how this applies to the figure.

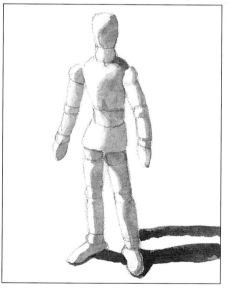

1 Paint the light side
Just as you did with the apple, draw the outline and paint in a light wash of Cadmium Red Medium and Yellow Ochre, using a no. 8 round. Check the value when dry. Mine dried at a value 2.

2 Paint the shadow side
Add the shadow side using a value 6 mix of Cadmium Red, Yellow Ochre and Manganese Blue. Add Ultramarine Blue for an even darker shade, and paint the cast shadow.

2) Identify patterns of darks and lights with value sketches

Every painting should start with a value plan or sketch, which simply maps in gray scale where the darks and lights will go in the painting. If you lose sight of this plan somewhere during the painting process, your painting will very likely self-destruct.

A value sketch should capture the bare bones of the subject's value patterns, leaving out all other detail. It should be a quick, rough idea of the subject done with a pencil, marker or brush and should not concentrate on accurate drawing. The worth of a value sketch is that it makes you focus all your attention on value without worrying about color or paint consistency or anything else.

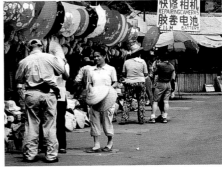

Reference photo
Make a line drawing from this reference photo or from one of your own. Transfer the line drawing to your watercolor paper.

Make a pencil value sketch
Use the reference photo to make a value sketch. Use a soft-lead pencil, such as a 4B or 6B. Use the broad side of the lead to hatch in the shapes of the middle and dark values (massing), leaving untouched paper for the lights. This practice will help you avoid outlining objects and adding details. You're just after the basic value pattern!

Lift lights to make a value sketch
An alternate method for creating a pencil value sketch is to fill in a solid rectangle with the side of your pencil, and then lift out the whites and lights using a kneaded eraser. This method follows the subtraction or elimination process of thinking. It can work well for artists, like me, who prefer to think like a sculptor starting with something that's already there and then taking away from it until the desired finished product is left.

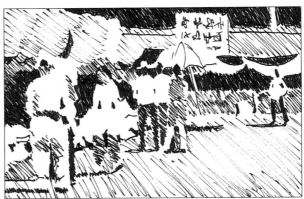

Try an ink and value sketch
Using ink or marker forces you to be quick and spontaneous because there's no erasing! Get it down quickly and leave it. If you mess up, do another one. Leave a lot of white space between your hatch lines to get the middle values, as you can't use lighter pressure on a marker to create a light value like you can with pencil.

Try a watercolor value sketch
Create a good black or really dark gray by mixing Ultramarine Blue and Transparent Oxide Red nearly full strength. Lighten the mixture with water to make a middle value. This method involves a little more effort, but it will help you get used to seeing pigment as a value instead of a color.

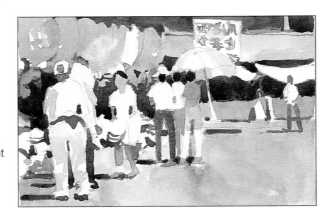

Artists need to learn to visualize a subject in black and white. A very simple way to do this is to copy your reference photographs in black and white and paint from them this way. If you do this for a while, thinking in gray tones instead of colors will soon become second nature to you.

Color can be distracting
Sometimes the myriad of colors in a scene can distract us from distinguishing values clearly. One specific area may exhibit many different colors and yet encompass only one value.

Values are more prominent in gray scale
When we look at a subject in black and white without the distraction of color, it suddenly becomes much easier to identify the light, middle and dark values or tones.

Another way to see in monotones rather than colors is to purchase a small piece of red Plexiglas from a plastics store and place it directly on your reference photo. The red will dominate all other color and only relay value back to your eye. This tool can also be helpful in checking the value pattern of your finished paintings by looking through it.

Red Plexiglass
This Plexiglas is 1/16-inch (2mm) thick and cut to a 4" × 6" (10cm × 15cm) rectangle so it fits a photo perfectly. Red acetate will work too, but it will not be as durable.

Compare the portion under the red Plexiglas
Notice how in the part of the photo covered with the red Plexiglas, there is a neutralizing effect on the color, allowing the eye to see value more clearly.

Neutralize the color
Place the Plexiglas over the entire photo. Now the eye sees no color at all; it sees only value patterns of lights and darks.

5 Squint at the subject

You have probably heard the advice to squint at your subject in order to see values better. When you squint you let less light into your eyes, which limits the myriad of values you're capable of seeing with your eyes fully open. Squinting literally narrows things down to three basic values—light, middle or dark—and forces any "undecided" values to commit to one of those three categories.

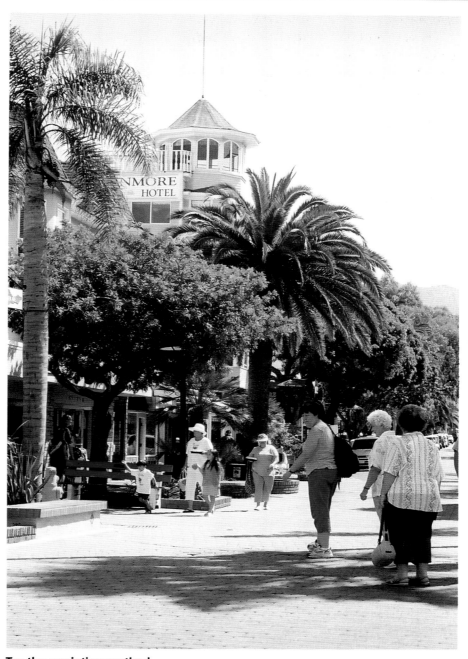

Try the squinting method

If something looks lighter when you squint, it belongs in the light value range; if it looks darker when you squint, put it in the dark value range. If it stays the same, it's in the mid-value range. Don't just think you understand this concept. Try it on other photographs and you'll really see how squinting helps in identifying values. Any onlookers might think you have a vision problem, but whatever helps us be better artists is worth the embarrassment, right?

6 | Create monochromatic paintings

In order to help you concentrate solely on value, it's a good idea to practice removing color considerations completely. That's where monochromatic paintings come in. Choose a pigment, such as Ultramarine Blue or Burnt Umber, that has the capacity to create a wide range of dark and light values. A yellow straight from the tube cannot get any darker than a middle value, so it won't work for this exercise.

Reference photo
Make a line drawing from this reference photo or from one of your own. Transfer the line drawing to your watercolor paper.

1 Begin with the whites and lights
Begin by covering the light areas with a watery wash of Burnt Umber, using a no. 2 mop. Leave the white areas untouched, and paint quickly and loosely. Let this wash dry completely before moving on.

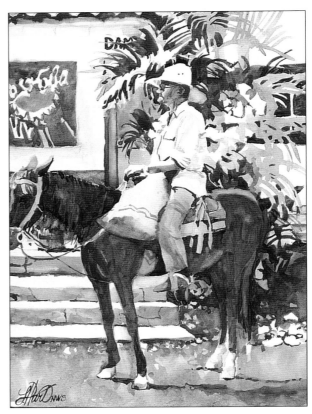

2 Add the middle and dark areas
Using more-concentrated mixtures of Burnt Umber, paint the midvalue areas with a no. 8 round. Add the small darks and details at the end with almost full-strength pigment.

Paint directly over a value sketch

Materials

PAPER
Watercolor paper

BRUSHES
No. 8 round

PIGMENTS
Alizarin Crimson, Cadmium Red, Manganese Blue, Transparent Oxide Red

OTHER
Pencil
Kneaded eraser

Painting directly over a value sketch is a good way to translate value into color. It's sort of like doing a paint-by-number painting, but you match colors to values instead of colors to numbers.

The Old Masters often used watercolor directly over charcoal, which is basically the same idea as painting directly on a value sketch.

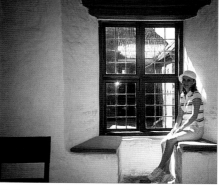

Reference photo
Pay attention to the pattern of light shapes.

1 Make a careful value sketch

Using either the reference photo or this drawing, complete a comprehensive value sketch. Map out the three basic areas of light, middle and dark values.

2 Match the pigment values to the values of the pencil

Using the no. 8 round, put puddles of Alizarin Crimson, Manganese Blue and Transparent Oxide Red on your palette. Fill in all the midvalue areas of the value sketch with midvalue mixtures of these three colors, carefully avoiding the white areas.

At first the pencil will provide some resistance, but the paint will soon penetrate it, creating a lovely texture. After this dries, add dark mixtures of these same three colors to match the dark areas. For the flesh-tones, use Cadmium Red alone and in combination with the other three colors.

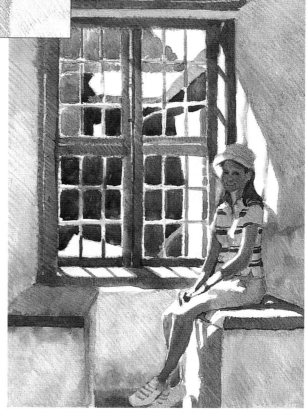

It's important that every painting contain three basic values—light, middle and dark—but they should not appear in equal amounts in a painting. To make this concept easier, think of it in terms of having a papa-size value, a mama-size value, and a baby-size value.

Let the middle values reign

Typically the midvalue range dominates the composition, taking up about two-thirds of the painting. Middle values act as the "glue" to hold the darks and the lights together in the painting. They are often the larger, less interesting areas of the painting and provide a backdrop for the focal point, where the darkest darks and lightest lights should be.

Equal equals boring

Although there are some instances in which the darks or lights will dominate the largest area of the painting (called a low-key or a high-key painting, respectively), the important thing to remember is that there should never be an equal amount of all three values, or the design becomes boring. An uneven ratio between the three will provide a more interesting balance. Here, I have diagrammed the value ratios in the painting on page 53.

Middle values
The middle values take up about two-thirds of the total area and tie the darks and lights together.

Light values
The light values in this example (which I have colored in to make them easier to see) take up the smallest amount of the painting.

Dark values
The dark values occupy the next largest area.

Place your subjects in strong light

Placing your subject in a strong light source helps you see values better because it creates a distinct light side (light values), shadow side (middle values) and cast shadow (dark values). Lights and darks alone can show two-dimensional shape (height and width), but middle values are required to create the illusion of three dimensions. Middle values can make a person's arm or leg appear as if it is turning in space, giving it form.

Every plane change or directional shift on an object creates a change of value because the light hits it at a different angle. A strong light source makes it easier to see the subtle transitions in value as something turns away from or into the light.

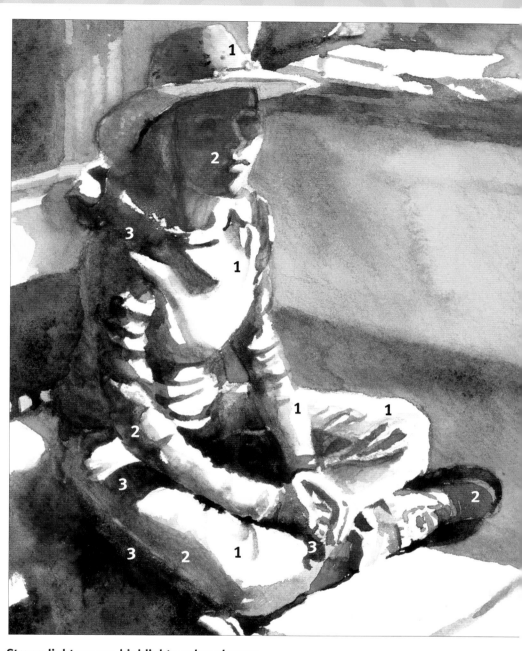

Strong light source highlights value change

Using a strong light source creates three distinct value areas: light side, shadow side and cast shadow.

1 Light side (light values) is the area where the light source hits the model directly, which I have left as white paper.

2 Shadow side or form shadow (middle values) is the area where the model turns away from the light source and shows the transition of values.

3 Cast shadow (dark values) is the area where the figure or a part of the figure is casting a shadow by blocking the light.

Watercolor pigments, most notably darker values of watercolor pigments, are about one degree lighter when dry than they appear when wet. This is a major issue that can keep us from getting our values right.

The best rule to follow is that if it looks right while it's wet, it won't look right when it dries. Apply watercolor values, especially darks, about one value degree darker than you want them to be when dry.

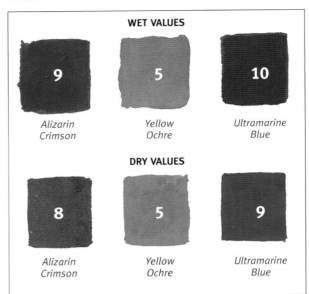

WET VALUES

9 — *Alizarin Crimson*

5 — *Yellow Ochre*

10 — *Ultramarine Blue*

DRY VALUES

8 — *Alizarin Crimson*

5 — *Yellow Ochre*

9 — *Ultramarine Blue*

Does watercolor really dry lighter?

I painted the three top squares Ultramarine Blue, Yellow Ochre and Alizarin Crimson and photographed them while they were still wet. Then I painted the bottom three squares in the same three colors and let them dry before photographing them. The darker paints, the red and blue, dried about one value degree lighter, while the yellow stayed about the same.

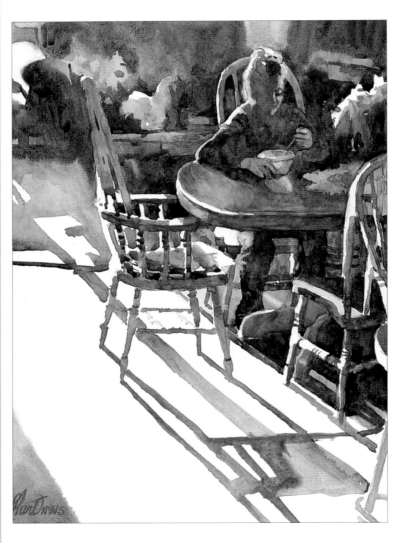

I had to majorly overstate the darks in this low-key painting in order for them to dry at value 10.

BROOKE AT BREAKFAST
WATERCOLOR ON PAPER
14" × 11" (36CM × 28CM)

Get It Right the First Time

My two brothers have a slogan in their construction business: "Get it right the first time." Adhering to this advice helps them avoid costly mistakes. This slogan should be ours too when it comes to painting values. Getting it right the first time means not having to go back to readjust values, which can rob a painting of its freshness. I've overworked many paintings by having to go back to strengthen weak values. To avoid this, apply your dark values at least one value degree darker than you want them to be.

Value does the work

Chapter Four Summary

- A painting will work with arbitrary colors as long as the values are accurate.

- A ten-degree value scale allows you to accurately figure shadow-side values.

- Every painting should start with a value sketch to identify the light and dark patterns.

- We need to train ourselves to visualize things in black and white.

- It's important to vary the amounts of light, middle and dark values.

- Middle values are the glue that hold the darks and lights together in the painting.

- Three values (light, middle and dark) are required to create the illusion of depth or form.

- Values in watercolor, especially darks, need to be overstated one value degree so they will dry to the proper value.

If I had to choose between color and value to work with, I would choose value. Color adds visual stimulation, but only value can create dimension. Imagine a painting as a dinner entrée: Color is the garnish that feeds the eye, but value is the meat that nourishes the soul. Color may get noticed first, but value is what makes the painting work in the end.

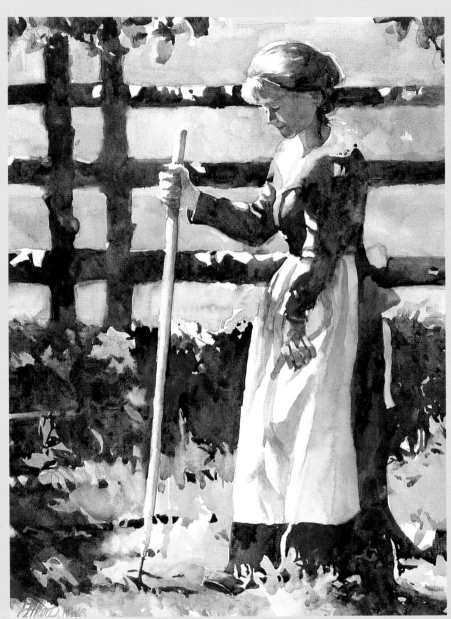

Color is certainly an appealing part of this painting, but value really makes it work by setting off the shapes of the focal area.

TAKING A BREAK
14" × 11" (36CM × 28CM)

Color Mixing and Watercolor Technique

Watercolor is an exciting and challenging medium to work with because of its somewhat headstrong nature—it does what it wants to do. Sometimes it seems like a living thing with a mind of its own, and, like a wild stallion, it will respond better if you work with it rather than against it. If you try to pull a horse with a rope, the animal will likely resist you; but if you walk beside the horse, leaving a little slack to the rope, the horse will walk with you. If you stifle watercolor by taking away its ability to behave as nature intended, it's like constricting a horse to a corral. Both were born to run free.

This chapter will teach you how to work with the medium so it can become your friend. Included are some easy ways to mix beautiful, clean color and some basic watercolor techniques to help you create paintings with figures that seem alive and vibrant.

In this painting, color harmony is achieved by limiting the palette to the primary colors, which, paradoxically, creates unlimited color combinations

CARMEL MISSION
14" × 11" (36CM × 28CM)

Set the temperature

There are only two pertinent questions to ask ourselves when it comes to color. The first question—"Is it dark or light?"—establishes its value. The second question—"Is it warm or cool?"—establishes its temperature. The least critical color question is "What color is it?" because if you get the value and the temperature right, matching the local color is not even necessary.

What is color temperature?

The color wheel can be divided into two halves: a warm side and a cool side. Warm color tends to advance, while cool color recedes. Temperature can make bold areas of your paintings come forward or subdue subtle areas into the background.

Make the most of temperature differences by contrasting warms and cools against each other too. A color is enhanced when it's played against its opposite. For example, red is much more intense when played against its opposite on the color wheel (its complement), green. To make a color appear warmer, place it alongside a cooler color. To make it appear brighter, use it next to a neutral gray.

When painting people, we can make fleshtones appear warmer by playing them against cooler shadow areas on the face. We can also use greens, blues, purples and other arbitrary colors we wouldn't ordinarily think of as fleshtones, as long as they are the correct values and temperatures.

Warm side　*Cool side*

The color wheel
Warm colors lean toward yellow, while the cool colors favor blue. (Think sun and water.) You can feel the different mood each side evokes. Keep a color wheel handy so you can quickly figure any color's complement.

To play up warm colors, add some cools
The cool purples and blues in this painting enhance the warmth of their complements, the oranges and yellows.

MORNING MEDITATION
11" × 14"
(28CM × 36CM)

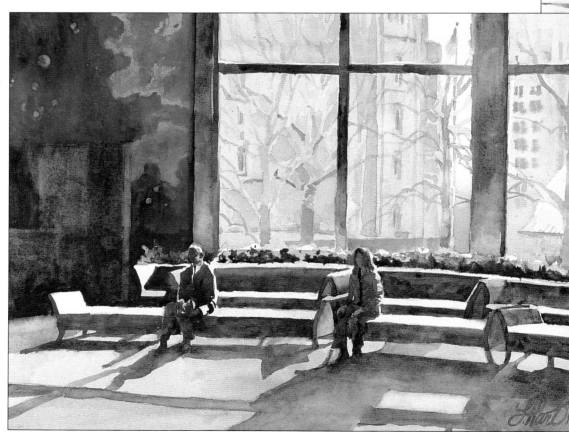

Contrast warm and cool colors

Colors become more intense when you play them against their opposites. A red will seem more vivid near its opposite, green, than it does when it stands alone.

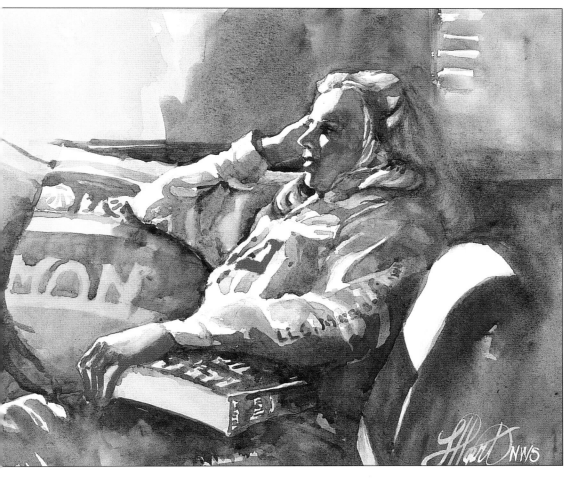

Enhance warm skin tones with cool backgrounds

Here, the Cadmium Red and Yellow Ochre in the face are enhanced by the cool touches of blue in the shadows and the purples of the clothes and background.

BROOKE READING
11" × 14"
(28CM × 36CM)

Color combinations that work

You can study color theory, trying to memorize complicated color schemes until you're blue in the face, or you can take a more "primary" approach to color by painting with *primary triads*. A primary triad is simply a combination of the three primary colors: a red, a yellow and a blue. With the three primaries you can create every other color you need, so your palette is limited and gives a more harmonious look to your work. Sometimes too many colors can be a hindrance to a painting.

Triads for underpaintings and mood

To make the most of primary triads, remember what you learned about value

in the previous chapter. Your triads will differ based on their values.

High-key color triads are those that are made by choosing three primaries to create a colorful and light-value triad. These are useful for underpaintings.

The primary triad

This is an example of a primary triad: Alizarin Crimson, Manganese Blue and Gamboge. This sort of high-key triad serves as a basis for the underpainting in most of my paintings.

HIGH-KEY TRIADS [LIGHT-VALUE TRIADS]

Alizarin Crimson, Yellow Ochre, Manganese Blue

Alizarin Crimson, Gamboge, Manganese Blue

Alizarin Crimson, Raw Sienna, Manganese Blue

Alizarin Crimson, Transparent Oxide Red, Manganese Blue

LOW-KEY TRIADS [DARK-VALUE TRIADS]

Transparent Oxide Red, Raw Sienna, Manganese Blue

Transparent Oxide Red, Yellow Ochre, Manganese Blue

Alizarin Crimson, Transparent Oxide Red, Ultramarine Blue

Transparent Oxide Red, Raw Sienna, Ultramarine Blue

**Note that Transparent Oxide Red can be used as a red or a yellow.*

My favorite high-key and low-key triads

Low-key color triads are made up of three primaries that have the pigment strength to create dark values. These may also contain one or more grayed primaries to mute or tone down the color brightness. These are great for shadows and moodier dark areas.

Set mood with your color schemes

Using high-key and low-key color schemes has much to do with setting a mood in a painting. High-key paintings are those in which the value range stays mostly in the first half of the value scale.

Low-key paintings are mostly made up of dark values, or those on the second half of the value scale. In the upcoming demonstrations, you will incorporate figures into finished paintings using both high-key and low-key triads.

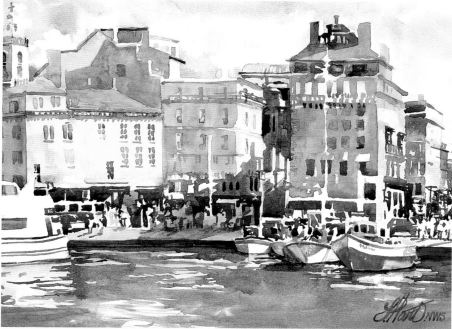

The high-key triad used to create the majority of *Marseilles Waterfront* included Alizarin Crimson, Manganese Blue and Yellow Ochre.

High-key painting

In this painting the values are mostly light, which results in a colorful and more upbeat mood to the painting.

MARSEILLES WATERFRONT
11" × 14" (28CM × 36CM)
COLLECTION OF THOMAS AND
JAMIE LOVE

The low-key triad used for *Park City Main Street* included Alizarin Crimson, Ultramarine Blue and Transparent Oxide Red.

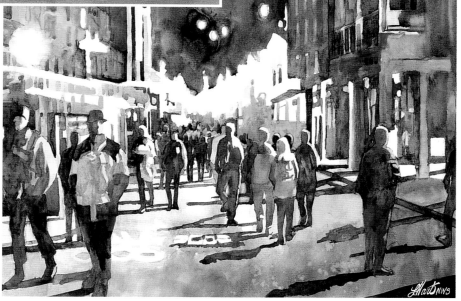

Low-key painting

In this painting, the dark values dominate, creating more muted colors and a more subdued feeling.

PARK CITY MAIN STREET
14" × 20" (36CM × 51CM)

63

Triads for fleshtones

The same color triads work to create fleshtones. The main difference is that you'll want a warmer red, such as Cadmium Red Medium, instead of Alizarin Crimson.

LIGHT SKIN COLOR TRIADS

Cadmium Red Medium, Yellow Ochre, Manganese Blue

Cadmium Red Medium, Gamboge, Manganese Blue

Cadmium Red Medium, Cadmium Orange, Manganese Blue

Cadmium Red Medium, Quinacridone Gold, Manganese Blue

DARK SKIN COLOR TRIADS

Cadmium Red Medium, Transparent Oxide Red, Manganese Blue

Cadmium Red Medium, Transparent Oxide Red, Manganese Blue

Cadmium Red Medium, Transparent Oxide Red, Ultramarine Blue

Cadmium Red Medium, Raw Sienna, Ultramarine Blue

My favorite fleshtone triads

These triad mixtures blend beautifully to create glowing, transparent skin color. Notice that in all of these triads the red is Cadmium Red Medium. This color is a very potent pigment I love using in fleshtone triads because it gives an intense warmth to the skin. But be forewarned, a little goes a long way in cadmium pigments. I usually only use Ultramarine Blue when I want a very dark skin color.

Light fleshtones

In this painting of my granddaughter Makenzie I used a fleshtone triad of Cadmium Red Medium, Yellow Ochre and Manganese Blue. Cadmium Red Medium and Yellow Ochre create a rosy complexion for fair skin. Manganese Blue is a light, high-key blue that helps keep the shadow areas from becoming too dark.

MAKENZIE
10½" × 7" (27CM × 18CM)

Dark fleshtones

This man from Bangladesh made a beautiful subject with his white robe setting off his beautiful complexion. I painted his skin tones using a fleshtone triad of Cadmium Red Medium, Transparent Oxide Red and Manganese Blue. Transparent Oxide Red adds a beautiful, glowing bronze color to darker skin tones while still allowing the fleshtone to stay transparent and clean.

TRAVELER
10½" × 7" (27CM × 18CM)

Cadmium Red Medium	Yellow Ochre	Manganese Blue

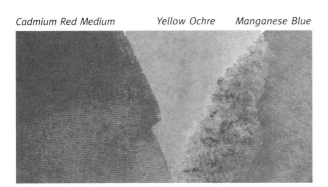

Light skin triad

Cadmium Red Medium	Transparent Oxide Red	Manganese Blue

Dark skin triad

The Watercolor Laundry Method

When we learned to do laundry, we were taught to separate our clothes into two batches of wash: lights and darks. I know it sounds silly, but this is a good rule to follow with watercolor also. I call this my *Watercolor Laundry Method*. The way it works is simple. Separate your work into two batches of wash: one for light values and the other for dark values. The lights go in first, and after they've dried (with a hairdryer), put in the darks. The first half of the value scale (values 1–5) constitutes the first wash, and the second half (values 6–10) makes up the second wash. That's the reason the value scale is marked with "wash 1" and "wash 2" on page 46.

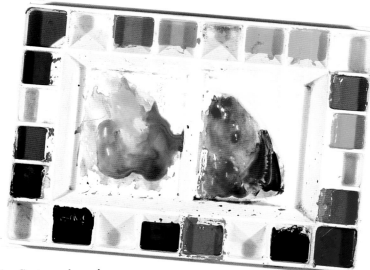

**The first-wash and
second-wash triads on my palette**
This photo shows the consistency of the first-wash and second-wash triads on my palette.

I usually keep them on opposite sides like this so I have a light side and a dark side, just like on the value scale. Notice how the three colors in each triad maintain their individual identity and yet are allowed to mingle slightly.

**First wash: the lights
(values 1 - 5)**
The first wash is made up of a high-key color triad (see page 62) and is used to paint the first half of the value scale. Your pigment consistency should be very juicy and wet—a little pigment to lots of water.

There are several advantages to this first wash: It loosens you up, it covers the page quickly and it unifies the painting.

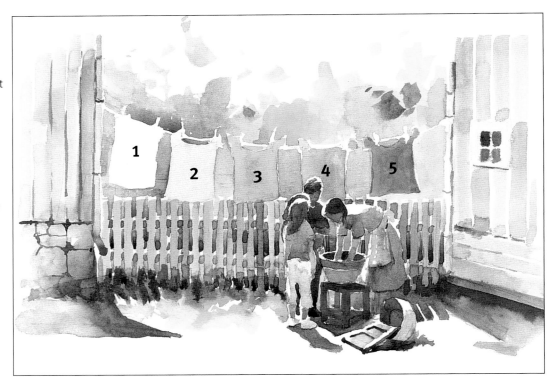

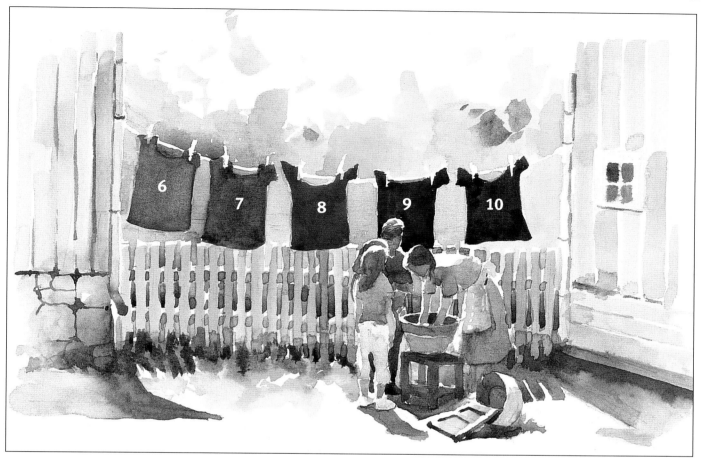

Second wash: the darks (values 6 - 10)

The second wash begins with a low-key color triad (see page 62), which can create the stronger, darker values of the second half of the value scale. Low-key triads tend to have a richer, more muted look than the high-key first-wash colors. In the second-wash phase, especially as you get to the final darks, the paint consistency rule is lots of paint to little water.

Paint Consistency Is Key to Wash Success

Proper paint consistency is responsible for watercolor's transparency. When watercolor becomes too muddy and dense, light cannot reflect through it. While mixing proper paint consistency cannot be learned through any other method except trial and error, here are some rules to help:

- Watercolor begins with water. Begin with lots of water and little paint, and end with lots of paint and little water.

- Keep your pigments fresh and moist. Dry colors on the palette mean dry and dead colors on the paper as well.

- Keep a spray bottle handy. Spray your paints several times during a painting session (use distilled water to prevent molding) because the paints will tend to get tacky as the water evaporates while they're exposed to the air.

- Keep the lid on. Always store your palette with the lid on it. You can keep using the same pigments for months as long as you keep them wet and covered and stir them often in the color wells.

Use the Watercolor Laundry Method to create a painting

PAPER
140-lb. (300gsm)
hot-pressed

BRUSHES
No. 2 mop
No. 8 round

PIGMENTS
Alizarin Crimson,
Manganese Blue,
Transparent Oxide
Red, Ultramarine
Blue, Yellow Ochre

OTHER
6B pencil
Kneaded eraser

It's time to put your washes together in a painting. I use this method a lot when painting from a photograph in my studio, which applies to nearly all of the paintings in this book. That's another benefit to painting from photographs. You have the luxury of building up layers of washes slowly because you can take the time to wait in between washes for the underpainting to dry.

Paintings done on location or directly from a live model are executed in a quicker, more spontaneous method you'll learn about in chapter six.

Reference photo
The cast shadows and the placement of the figures in the central band of light made this scene an appealing design to paint.

Drawing
Begin with a light pencil sketch to show the placement of the building, figures and shadow areas.

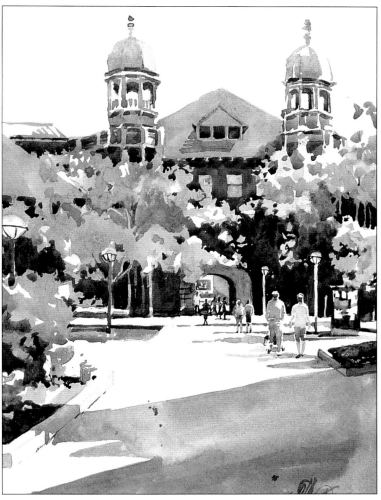

1 Apply the first wash

Using the no. 2 mop, wash on an underpainting using a high-key triad of Alizarin Crimson, Manganese Blue and Yellow Ochre. Keep the values within the first half of the value scale. Generally if you paint the first wash somewhere between values 3 and 5 it will have enough strength when dry to stay colorful. Start at the top and work down on a slant to allow the colors to blend and mix on the paper to get harmonious greens, purples and oranges. Paint around the whites to preserve them. Don't worry if this stage doesn't look like much. It should simply be one flat, colorful wash. Allow this to dry before moving on.

2 Apply the second wash

Switch to your no. 8 round and add the darker value. Switch to your no. 8 round, and add the darker values (the second half of the value scale) by re-wetting areas of the subject and painting over the initial wash in places using a low-key triad of Alizarin Crimson, Transparent Oxide Red and Ultramarine Blue. Paint the figures first, using a lighter mixture of the triad for the closer people. Then move to darker mixtures for the distant people near the shadow area. Add the darkest darks and details last. This second stage will not be applied as one continuous wash because it is broken up in places around the first wash, but it is all painted with the same low-key triad. It gets fun at this point because things begin to sharpen into focus as you carve out space behind objects and make them jump forward in the picture plane.

Keys to applying pigment

The least exciting pigment choice you can make is to simply match the local color of the photograph or object. Create colors that match your emotional response to the subject. This may mean using arbitrary or intuitive color. Experiment to find color combinations that express what you want to say.

There are two things you can do to ensure your washes are filled with expressive, clean color: Use granulation, and mix your paints on the paper rather than the palette.

Granulation is using water and gravity to allow pigments to subtly merge and blend on the paper by themselves. Use plenty of water so the paint is juicy and flows well, almost like melted butter on a hot surface, and keep your board on a slant that is not too steep and not too flat.

Mixing your paints on the paper instead of the palette allows your pigments to stay fresh and bright and avoid muddiness. Let your color combinations mingle on the palette, but do not stir them together unless you're looking for a dull color.

A flat surface traps the pigments
Painting on a flat surface does not allow the paint to merge and run at all; the colors stay separate. While there's nothing wrong with this color, it's not very expressive and looks dull and dry.

A slanted board allows granulation
Position your board at about a 30- to 35-degree angle to let water and gravity do their job.

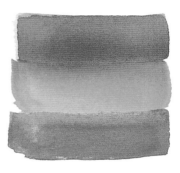

Let water and gravity do the work
Gradual color transitions happen when you allow water and gravity to mix the pigments. Although I used only a red, yellow and blue to paint this square, a myriad of other colors were created with granulation.

Mingle pigments on the palette
This is what your color combinations should look like on the palette. Allow them to mingle a bit on their own, but make sure they maintain their separate identities.

Palette-mixed watercolors lose life
Predictably, mixing three primary colors on the palette results in a muddy, lifeless hue.

Mixing pigments on paper adds spark
Using the same three colors mixed on the paper and allowing them to mingle however they will produces a much different result. This individualized color can't be duplicated or purchased. Keep this image in your mind when you think about color mixing.

The pull-down technique

Materials

PAPER
140-lb. (300gsm)
hot-pressed

BRUSHES
No. 8 round

PIGMENTS
Cadmium Red
Medium, Transparent
Oxide Red, Ultramarine Blue

OTHER
6B pencil
Kneaded eraser

In addition to the watercolor laundry method, the pull-down technique is a valuable method that employs granulation in painting a figure. I have also heard it referred to as "pulling the bead." The bead is the line of wet paint that accumulates at the bottom of a completed brushstroke when painting on a slant. When you return to the paper with a new brushload of paint, touch it into the bead of wet color and pull it downward, blending the colors together. Pulling the bead ensures lively color and beautiful melted transitions within figures. In using this technique, remember three important points:

- Paint from top to bottom.
- Use a slanted surface.
- Keep your paints juicy.

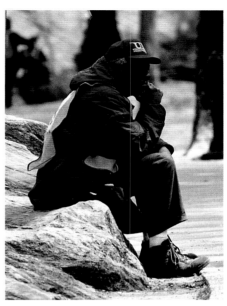

Reference photo

1 Establish the bead

Sketch the figure's outline, and then start at the top with the no. 8 round loaded with Ultramarine Blue. Paint the man's hat, letting the dark bead run to the bottom of the stroke. While this is still wet, pick up some warm Transparent Oxide Red and touch it into the wet blue pigment, pulling it down into his face.

2 Charge the bead with new color

Finish the face and hand with Transparent Oxide Red, then reload the brush with Ultramarine Blue. Touch it back into the wet pigment to paint the shirt collar. Allow the bead to run to the bottom of the hand and neck.

3 Work quickly

Using the same brush loaded with Ultramarine Blue, keep pulling the bead, painting around the light areas of the sleeve. Move quickly so the bead doesn't dry out; otherwise you'll have a hard edge. Timing is everything in this technique.

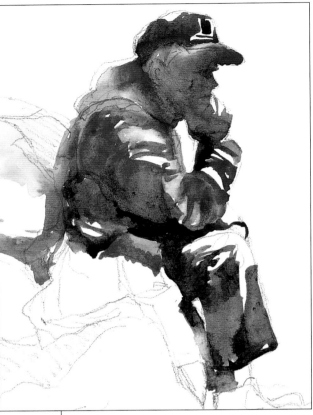

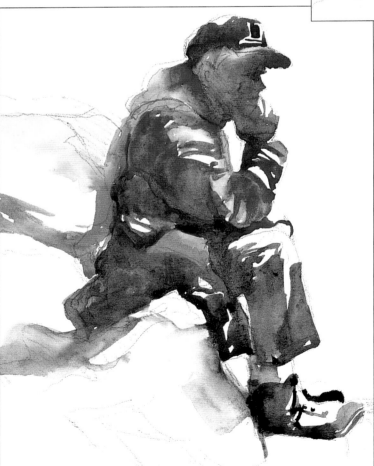

4 Vary the color temperature

Add some warm Transparent Oxide Red to the cool blue under the sleeve of his shirt for interest. Mix these two pigments on his pant leg. Rinse your brush, and paint the rest of the vest with Cadmium Red Medium.

5 Don't go back in

Touch back into the wet paint bead with a mixture of Ultramarine Blue and Transparent Oxide Red to paint the jacket lying on the rock. Paint the shoes with these two pigments as well, leaving the sunlit areas as white paper.

The beauty of this technique lies in its simplicity. The temptation will be to go back and add more detail to the figure, but this rarely helps and almost always fractures it with hard edges. Maybe a few minimal darks can be added, but look how fluid and loose this figure is when left just the way it is.

A Pigment an Inch

One of my former art teachers used to say you should never paint more than an inch without changing the color.

Thoughts on finding the perfect medium

Chapter Five Summary

- There are only two considerations in choosing color: Is it dark or light? Is it warm or cool?

- Using contrasts will enhance color.

- Limiting your palette to primary triad color schemes will add harmony to your paintings.

- Proper paint consistency is responsible for watercolor's transparent glow.

- Classic watercolor technique starts with lots of water and little paint and ends with lots of paint and little water.

- Clean, individual color depends on the use of granulation (water and gravity) to mix paint on the paper.

- Pull the bead to use granulation to its fullest potential and to create lively paintings.

An artist, fed up with his watercolors not doing what he wanted them to, went to his art dealer to find a better brand of paints that wouldn't fade, would lift easily, was totally transparent, and *never* made mud. "Do you know of a brand of watercolor that can do all that?" he asked.

"Certainly," replied the dealer. "It's called 'A Pigment of Your Imagination.'"

Wouldn't it be great if there was such a perfect pigment? The reality is that we have to deal with the unique characteristics and challenges of watercolor. After all, these are the things that make this medium so appealing.

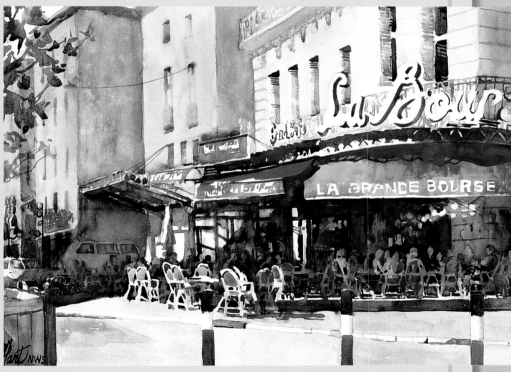

When you allow watercolor to do what it does best by letting it mix and mingle on a slanted surface, you allow the medium to help you create vivid, expressive color combinations. The beautiful transition from yellow to orange to red on the awning was created by letting the colors run together on a slanted surface. The warm colors show up more vividly by being placed against the cool colors used in the shadows under the awnings.

LA GRANDE BOURSE
14" × 22" (36CM × 56CM)
COLLECTION OF THOMAS AND JAMIE LOVE

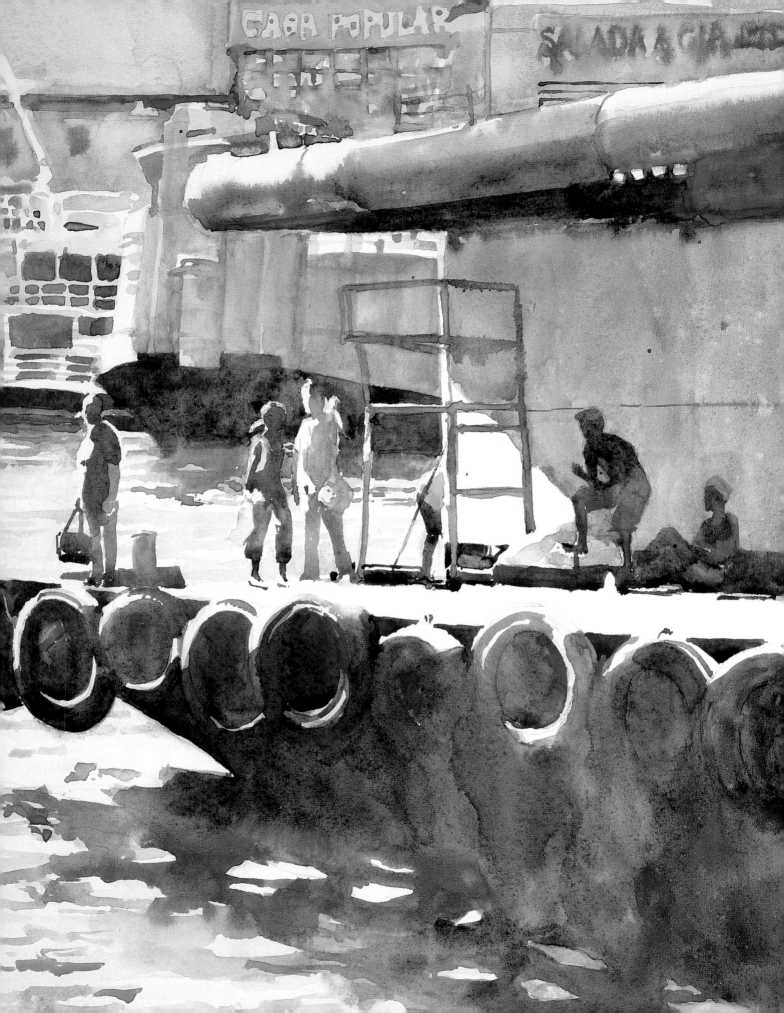

Painting People From Life

If I had to name one single factor that lifted my work away from the ordinary, it would be my journeys into the Great Studio Outside.

—JOSEPH ZBUKVIC

We can do our banking online, shop by mail-order catalog, gas up our cars without a cashier, take classes by correspondence, carry on conversations via answering machines and so on. It's very possible to go through an entire day without any real human contact. Sometimes we just need a little personal contact to remind us that we still belong to the human race.

As artists, we can get so far removed from life by painting from photographs in our studios that our paintings can become somewhat stale. Painting on-site or from a live model from time to time can reconnect us to life and inject a little spark of excitement back into our work.

For many years I never painted from life, as the challenges it presented seemed too formidable. I found the experience extremely frustrating and challenging at first—there was *so* much subject matter to tackle, and conditions were constantly changing. But I kept going and gradually began to get a handle on it.

I now consistently spend small amounts of time working from life. There are valuable lessons there that you can't get any other way. If you spend a little time, even just a half hour a week, painting outside or from a model, you will eventually gain strengths that will revitalize your paintings and carry over into your regular studio work.

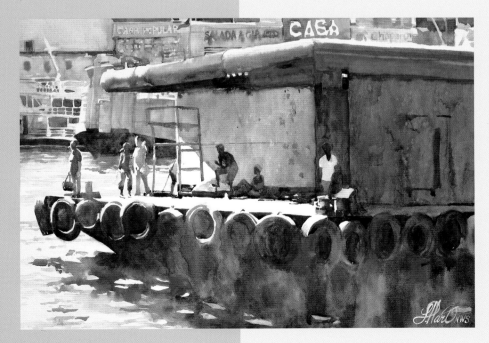

Live-figure studies lead to extraordinary paintings

This painting could not have been created on location, because it was a quickly passing scene on the Amazon, but the task of capturing the actions and gestures of the people was made easier by the many figure studies I've done from life.

ALL TIRED OUT
14" × 20" (36CM × 51CM)

On-location painting success

I've learned a few things over time that have helped me paint more successfully on-site. You'll discover more on your own as you work.

- Make your on-site painting kit small and easy to transport. Keep it somewhere accessible. If it's at all inconvenient, it's likely you won't use it. (See page 14.)
- Paint in small blocks of time not longer than a half hour.
- Paint small. You can learn more from painting many little sketches than you can from doing one large one.
- Paint in the shade or use a white umbrella that clips onto your chair to shade your work. This is important to keep you from making inaccurate color and value judgments in bright sunlight or from a colored umbrella.
- Eliminate! Don't try to include everything you see—it's impossible. Focus on getting the essence.
- Stick with one light-and-shadow pattern throughout your sketch, even though it might change significantly in a half hour's time. Pencil in the light shapes quickly, and brush in the shadows at the beginning. Don't change them.
- Keep going even if you make glaring mistakes.
- Be persistent! If you keep at it, one day soon you'll take home a fresh little painting so full of life and energy that you'll surprise yourself.
- Be patient and look for some little thing to compliment yourself on each session.

6 Benefits to Painting From Life

1 It helps you realize that firsthand information is the best source because it creates the strongest link between artist and subject.

2 It injects excitement and energy into your work by forcing you to paint spontaneously.

3 It forces you to simplify, helping you avoid overworking. This capitalizes on watercolor's freshness.

4 It teaches you to paint from memory.

5 It makes your work improve under pressure because it forces you to face and resolve problems quickly.

6 It relieves you of the pressure of having to produce a successful, completed work of art.

Keep it small

Paint little sketches in small blocks of time, using your compact on-site painting kit. In these little color sketches I did on-site at Newport Beach, I didn't worry about trying to get it all in. Simplify by eliminating much of the subject matter, and wait until the end to add details. Your reward will be a charm and freshness that can't be produced in the studio from a photograph.

5 steps for painting on location

A beach or park at a time of day when there is good light and a lot of people is the best place for painting on location. Most often, I just park my car and capture in my sketchbook people who have no idea they're being scrutinized.

Before you begin using a full palette to paint figures from life, practice the following steps. When you've spent some time practicing these, move on to your full palette.

1. Practice gesture drawings
Use a 6B drawing pencil to scribble a series of loose, directional strokes to get down the essence of the action and to capture the gesture and motion of the person.

2. Paint silhouettes in one wash
Without any previous drawing and without lifting your brush, use one color and a small round to get the whole figure in one shot. Figures outside are generally moving, so work fast. Take a good look at a pose, and freeze it in your mind. Painting from life forces you to rely on the visual image imprinted in your mind. Eventually you will store up a mental "bank account" of poses.

3. Divide the body into segments
Separate the body into segments where it hinges naturally: divisions between joints at the upper and lower body, the knee, the elbows and the ankles. The walking or running figure is in a continual state of losing its balance, so limbs are extended as counterbalances to keep it upright. When the arm is forward in the striding figure, the leg on that same side of the body will be back.

4. Add a light pattern for dimension
Once you are comfortable with capturing quick silhouettes, add a light pattern. Pick out one "victim," and stick with that person long enough to create several sketches of him as he moves in and out of various poses.

5. Add more color
Use the pull-down technique (page 71) to create a smooth melting of color throughout the figure.

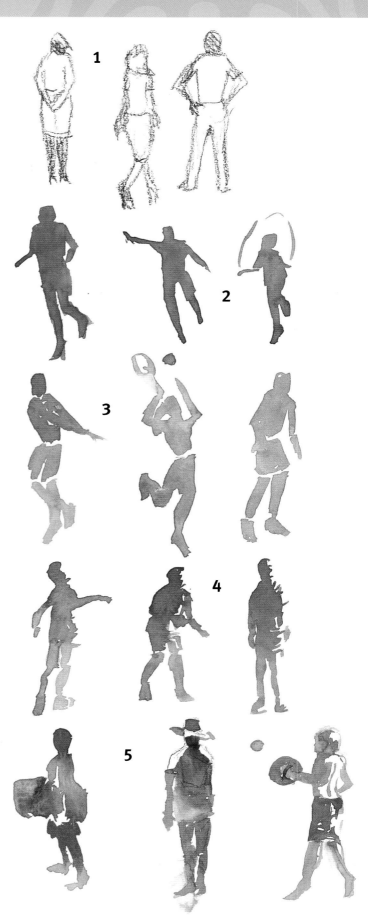

Basic figure proportions

While it isn't critical to have a complete knowledge of human anatomy to paint a convincing figure, you still need a simple understanding of basic figure proportions so your figures do not look distorted.

The most important part of the body to keep proportionately accurate is the head. Once you establish the individual head size, you can use it as a measuring unit to help you accurately depict other body measurements such as total height, width of shoulders, etc. (Only a person's own head should be used to compare in size to her other body parts.)

Be aware, though, that the head is not a foolproof unit of measure; there can be variations. Body proportions vary from person to person, and these proportions change depending on what position your subjects are in and the angle from which you are viewing them.

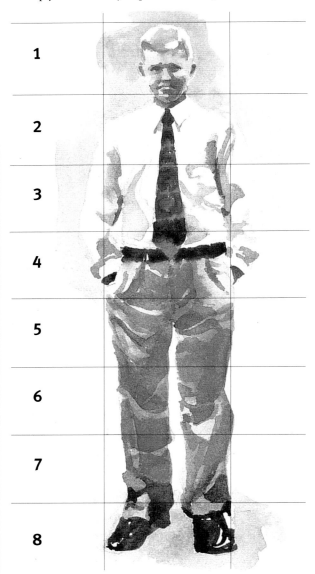

Adult male figure

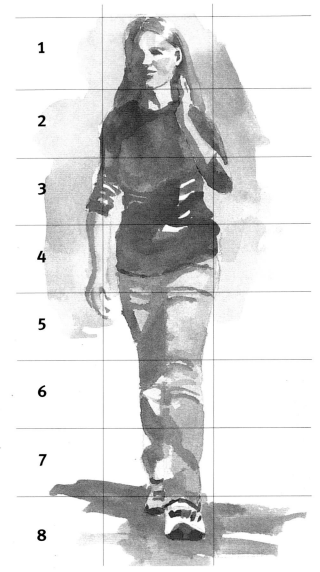

Adult female figure

Each square of the grid represents one head size.

1 The average height of an adult male or female is between seven and eight heads high.

2 The crotch will generally fall halfway between the top of the head and the bottom of the feet.

3 A man's shoulders are about three head widths.

4 A woman's shoulders are narrower, about two head widths.

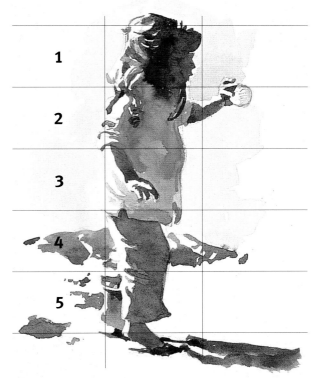

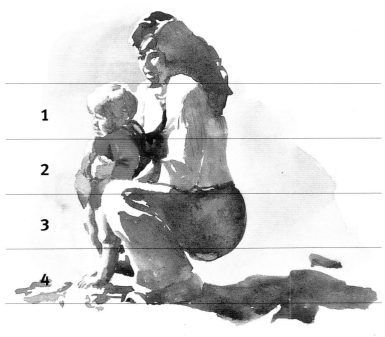

Child figure

1 At age three, the child is about five heads high.

2 The head is much larger in relation to the body in young children.

3 Children's feet are shorter than the length of their head, while adults' feet are about one head length long.

4 The legs in children are much shorter than an adult's, compared to total body height, making the midpoint fall somewhere within the stomach region.

Toddler figure

1 The head takes up roughly one-fourth of the total body height.

2 The facial features are in the lower half of the head, making the head seem much larger than an adult's.

3 Cheeks are rounder and chubbier.

4 In some cases, like this squatting figure in which body limbs are bent, you may not be able to use the head measuring system. If you're working from a photo you can measure the length or width of the body parts with a ruler, and then transfer those measurements to your drawing by enlarging them proportionately to one another. The bottom line is that if you train your eye to see accurately, you will be able to draw accurately.

Using the Spontaneous Method: working from a model

Materials

PAPER
¼-sheet 140-lb.
(300gsm) hot-pressed

BRUSHES
No. 8 round

PIGMENTS
Alizarin Crimson, Cadmium Red, Gamboge, Manganese Blue, Ultramarine Blue

OTHER
6B pencil
Kneaded eraser

Painting from posed models offers an advantage that candid outdoor sketches of people don't often allow: a subject who is holding still! In working from a model in the studio, you should follow much the same routine as when painting outside on location.

I call this the *Spontaneous Method*. This is essentially the antithesis of the Watercolor Laundry Method we've used so far. In spontaneous painting you try to get everything down in one shot, beginning at the focal point.

Seat the model in a sunny spot near a window. If it's nighttime or cloudy, try an indoor spotlight that simulates natural sunlight. The closer this is placed to the model, the stronger the light-and-shadow pattern will be. Take photos of the pose without a flash (so it doesn't flatten out the shadow pattern) so you can come back later and work when the model is not available.

Spontaneous painting
In spontaneous painting, begin at the focal point (in this case, the model's head), and work out from that. Then, if you only get that much recorded, you have at least captured the most important part. Here, I brushed in her face all at once, with no second chances and no stopping for things to dry.

Reference photo
The late-afternoon light coming through the window of my studio created this dramatic scene, which I shot without using a flash on my camera.

1 Create a gesture drawing
Quickly sketch a brief preliminary drawing to get the model's placement and gesture on the page.

2 Start with the focal point
Since the focal point in this painting is the model's face, you'll want to start there. Paint it quickly using a no. 8 round and Cadmium Red, Gamboge and touches of Manganese Blue. Skip over the light patches on the model's face and hair.

3 Work out from the focal point in all directions

Loosely wash in the background with a mixture of Alizarin Crimson, Manganese Blue and Gamboge, pulling it into the shirt. Leave the sunny patches of light as white paper. Use Cadmium Red and Gamboge on the arms, and use a mixture of Gamboge and Manganese Blue to indicate the abstract patterns of the plant foliage. Render the arm of the chair by painting the dark spaces behind it with Ultramarine Blue.

But It's Not Finished!

Spontaneous painting is not always about a fully polished work. You cannot expect to do a finished masterpiece in a half hour; sometimes an unfinished painting has more life to it than a completed painting anyway. A painting or sketch left in a state of emerging is alive because it is still in the act of growing and becoming. Don't be afraid to stop at any point along the way if you hear that little voice inside say, "Quit!" I've ruined so many paintings by going a few steps too far.

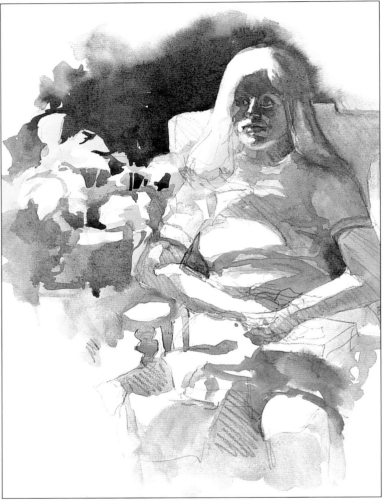

4 Add a final shadow

Add more of the shadow patterns on the face and legs using combinations of Alizarin Crimson, Manganese Blue and Ultramarine Blue. Use a much deeper combination of these colors in the background to set off the edge of the hair and the chair back in sunlight. This is as far as I got in this sitting with the model, and even though there is much of the sketch still undefined, I'm happy with the moody vignette it offers of my model in the sunlight.

Notice how the focal area (the face) is more defined than the other areas, such as the legs. The definition calls attention to the focal area as the most important part of the painting and contrasts nicely against the more abstract areas.

Semiworking from life: combining techniques

PAPER
¼-sheet 140-lb.
(300gsm) hot-pressed

BRUSHES
No. 2 mop
No. 8 round

PIGMENTS
Burnt Umber, Cadmium Orange, Cadmium Red Medium, Manganese Blue, Quinacridone Gold, Ultramarine Blue, Yellow Ochre

OTHER
6B pencil
Kneaded eraser
Masking tape

Another method I use to inject freshness into my work from time to time is what I call *semiworking from life*. This is where you use a quick color sketch done previously of the model for reference along with a photo of the sitting. Having the photo allows you to recharge your memory with information from the former scene with the model, while the quick study reminds you to eliminate extraneous detail and focus on the essence. Combining the two references in this way becomes a sort of check-and-balance system that lets you capture the best of both worlds.

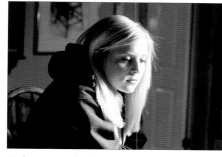

Reference photo
I placed a spotlight close to my model to create a strong light-and-shadow pattern on her face.

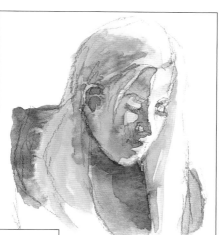

Reference sketch done From model
In this quick color sketch painted directly from the model, I gave myself only a half hour so I would not overwork the face. Setting a time limit forces you to focus on getting the big shapes down before worrying about details and helps you to get a handle on the basic light-and-shadow pattern. Do the same using the reference photo now; just force yourself not to spend much time on it.

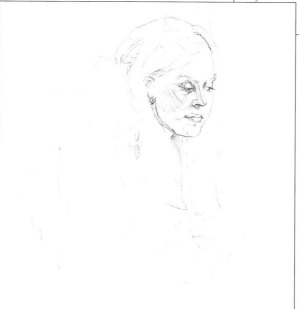

1 Create a gesture drawing
Using a 6B drawing pencil, I sketched the model's head and torso, lightly indicating the shadow pattern on her face. I could now get a much more accurate likeness of the model referring to the photo because I could take my time.

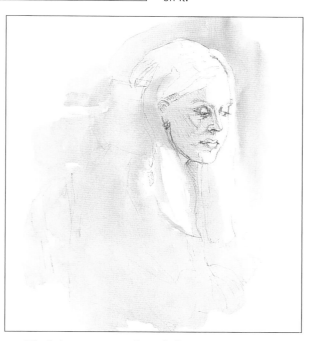

2 Wash in a warm underpainting
Because there is such a warm light being cast on the model, lay down an underpainting of Yellow Ochre and Cadmium Orange, using the no. 2 mop. Brush the underpainting over all areas except the areas in direct light. Allow this to dry.

3 Paint the face and hair

Switch to the no. 8 round, wet the area of the hair on the left side and flow in Burnt Umber, Yellow Ochre and Quinacridone Gold. Let the colors softly blur together. Mix a more potent batch using less water and more pigment. Test a swatch on a piece of scrap paper to make sure it has plenty of strength. Touch the flesh color of the face back into the wet hair so it leaves a soft edge, and continue pulling it down into the cheek, eye socket and nose. Use a mixture of Cadmium Red Medium, Yellow Ochre and Quinacridone Gold for the skin, adding Manganese Blue for the cool shadows along the nose and for the nostril and eyelashes. Soften the edges of the round surfaces of the face with a clean, damp brush. Wet the area of the hair on the right of the face, and paint a dark strip of Quinacridone Gold and Cadmium Orange, and finish painting the hair in shadow under the chin.

4 Add clothing and final details

Paint abstract shape of the model's sweatshirt with a flat wash of Ultramarine Blue and Burnt Umber. Leave the folds of fabric in the light unpainted, letting the underpainting show through. Soften some of the edges, and paint in the chair-back rungs with warm tones. Using both references helps create a very pleasing study of the model.

Put life in your art

Chapter Six Summary

- Keep your on-location painting kit as small and portable as possible and in a place that is easy to reach.

- Paint in small blocks of time to keep your energy level high and to avoid overworking.

- Paint in the shade, or use a white umbrella.

- Practice capturing the simple gestures and actions of figures from life.

- Use the head as a unit of measure to help gauge body proportions.

- Use the Spontaneous Method to capture a single idea all at once by beginning at the focal point and working out from there.

- The goal of on-location painting is to get down the focal point of the subject and not insist on a finished painting.

While this book focuses mainly on painting people from photographs, I strongly believe that artists should gain some firsthand experience in painting people from life. If we refuse to venture out from behind the safety of our art tables to the "great studio outside," we're somewhat like the grade school teacher who closed the blinds on her classroom windows so the passing circus parade of elephants, lions and tigers wouldn't interrupt her students' study of African wildlife. From time to time we need to go out and observe the parade of humanity. It will reconnect us to the human race and inject new excitement into our work.

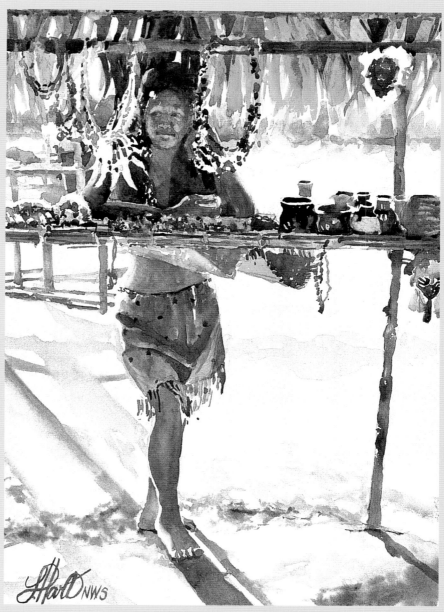

Painting regularly from life will inject into your studio work a freshness and spontaneity that will help you capture gestures and actions in a believable way. While I couldn't paint this Brazilian girl from life, I was able to observe her in person, committing to memory her beautiful bronze skin in the setting sun. I used that memory as much as the photograph as I painted her.

SELLING HER WARES
14" × 11" (36CM × 28CM)

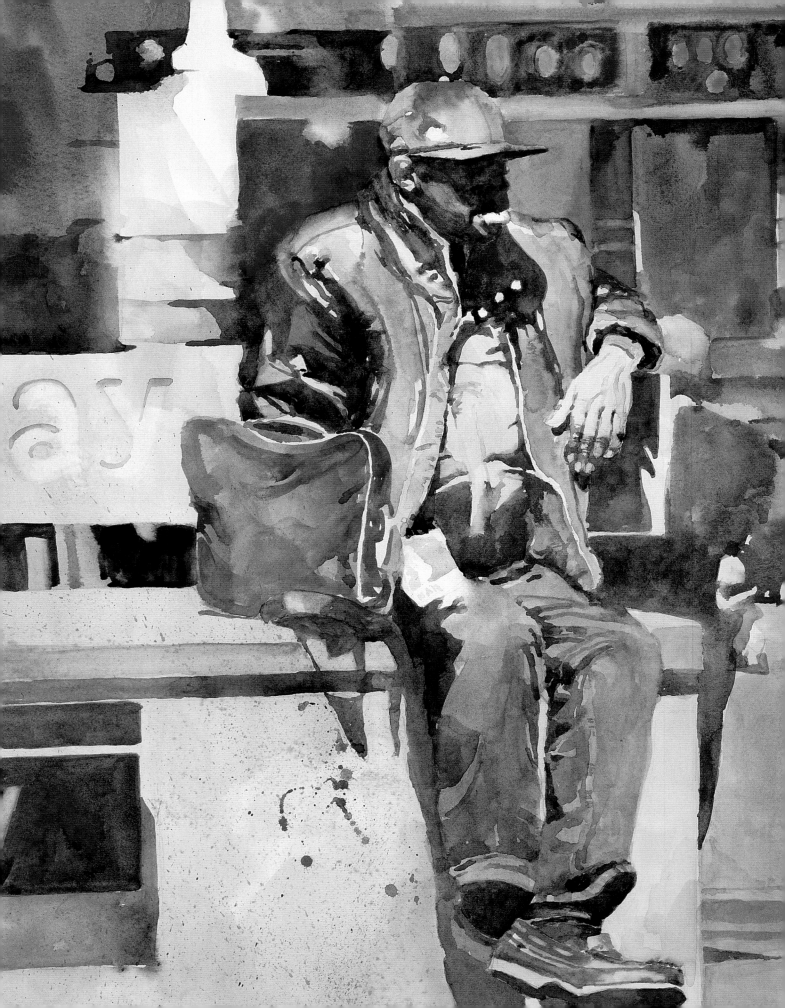

People as the Main Subject

The human figure is the most sensual of all subjects.

— MEL STABIN

At Christmastime, our family brings out the delicious candy assortments we receive as neighbor gifts. We tend to fight over certain ones, especially the homemade pecan logs. The sentiment is basically "Why waste your calorie allotment on something that doesn't satisfy like caramel and pecans?" Sometimes I feel that way about painting people: Why waste time on a painting that doesn't include a figure? While I'm not denying the value of abstract or landscape paintings, people are the most fascinating and emotionally satisfying subjects for me. And while much can be read from a model's facial expression, I prefer to capture the mood of a person's overall gesture, the way that person sits or stands or the shape of the silhouette.

Through the demonstrations to come, you will learn how to

- Create dimensional form at the focal point to pop the figure out from the background;

- Subdue less important areas of the figure by connecting them to the background;

- Use geometric shapes in the background to contrast with the rounder, more organic forms of the human body;

- Play a representational subject against an abstract background;

- Crop or pose the model in an unusual way to add more interest to a composition.

This painting is a good example of using an abstract background with a representational figure. One compliments the other. The appeal of this figure for me was the mood the slightly slumped posture conveyed: tired, but not beaten by life.

HEADING HOME
20" × 14" (51CM × 36CM)

Create dimension at the focal point

Materials

PAPER
140-lb. (300gsm)
hot-pressed

BRUSHES
No. 2 mop
No. 8 round

PIGMENTS
Alizarin Crimson,
Burnt Umber, Cadmium Orange, Cadmium
Red, Manganese
Blue, New Gamboge,
Quinacridone Gold,
Raw Sienna, Transparent Oxide Red, Ultramarine Blue

OTHER
4B or 6B pencil
Kneaded eraser
Masking tape
Paper towels
Spray bottle filled
with distilled water

When a person is your main subject, the focal point of the painting should be some part of the figure itself, usually the head and torso. Contrasting light and shadow patterns will help you create the illusion of depth or form within the model while you keep other areas of the painting as flat, two-dimensional space. Strategically placed sharp edges and value contrasts around the perimeter of the figure will make the figure appear to come out of the page, while diffused edges and connected shadow shapes will link it to the background. The beautiful marriage of these contrasts will make the painting work.

Value sketch
The design of this painting is based on the path created by the light shapes set off against the dark background.

Reference photo
During an unforgettable trip to Brazil, I received a most amazing and unexpected gift: permission to photograph a native tribe still living along the Amazon River. I later cropped this photo with my template so that the center of interest would be the face and torso area in bright sun.

Drawing
Tape a quarter sheet of paper to your board. Using a 6B pencil, draw the figure, hatching the shadow pattern lightly behind the light shapes.

1 First wash: Cover the paper, save the whites and loosen up

Clean your palette with a wet paper towel. Spray and stir your pigments. With a no. 2 mop, mix some bright, juicy puddles of Quinacridone Gold, Cadmium Orange, Raw Sienna, New Gamboge and Cadmium Red. Working with your board at an angle, apply this wash from the top down, leaving the white areas untouched. Each time you return to the palette, pick up a different color. Let water and gravity mix the colors. Use New Gamboge and touches of Cadmium Red and Cadmium Orange on the brightest feathers. Exaggerate the color so it will dry at about a value 3 or 4.

As you come into the shelves and ground, use a cooler wash of Ultramarine Blue and Transparent Oxide Red, and then paint the darker shadow bands on the left and right below the shelves with a more concentrated mixture of those pigments while the area is still damp. Add the foliage on the left of the figure with the same shadow colors so the edges are slightly diffused. Paint the brighter foliage on the right with Manganese Blue and New Gamboge. Let dry.

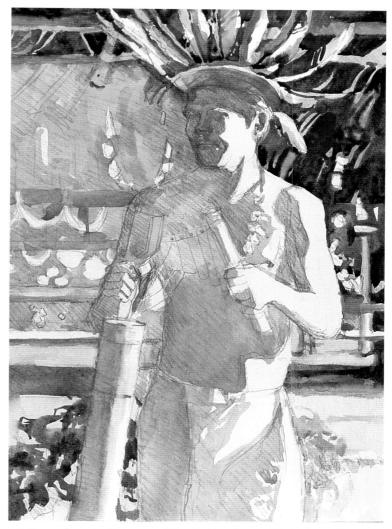

2 Second wash: Cut around the light values with darker values

Switch to the no. 8 round, and mix dark puddles of Burnt Umber, Transparent Oxide Red, Alizarin Crimson and Ultramarine Blue, letting their edges touch and bleed together on the palette. Begin at the top, and "carve out" the feathers by painting behind them, letting the underwash show through as highlights and sun patches. Whittle away the first wash, leaving little shapes of light. Carry this paint over to the left area of the roof, and let all the rich darks mix; paint around some of the support beams and grass. Soften edges in places. Think of weaving an abstract pattern of darks and lights as you work. Step back often to see the whole picture. Paint the dark pattern behind the man on the right side, leaving a hard edge where his shoulder and arm are in sun. Don't worry if background light shapes seem to compete at this point. Let this area dry.

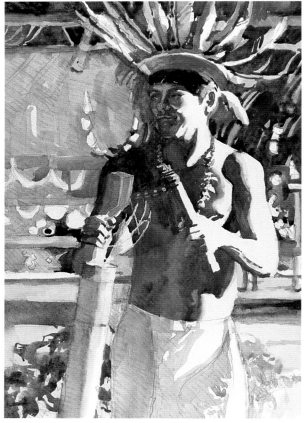

3 Second wash, continued: Establish the whites and loosen up

Use the no. 8 round to mix a pool of Raw Sienna for the hat brim. Touch into this wet paint with a brush-load of Ultramarine Blue and Transparent Oxide Red for the hair. Paint the face with Cadmium Red and Transparent Oxide Red, touching back into the damp hairline for a softened edge. While the face is still damp, soften the cheek with a damp brush, and add the eyebrows, eye sockets and shadow areas with a fleshtone mixture of Alizarin Crimson, Transparent Oxide Red and Ultramarine Blue. Wipe out some light areas on the face with a damp brush. Carry the warm fleshtone into the neck area, and add a touch of pure Cadmium Red. Paint the ear with this as well; thin areas of the body become translucent in sun. Work into the torso with mixtures of the dark flesh combination, leaving white paper for the hand holding the pipe, the arm, the chest area and the necklace shells in sunlight. As you get to the stomach area, warm the paint with pure Cadmium Red and Raw Sienna for the glow of skin in evening sunlight. Paint the left arm and hand, leaving the white shapes of the fingers and forearm as a hard-edged shape. Pull the outer edge of this arm into the background shapes behind it.

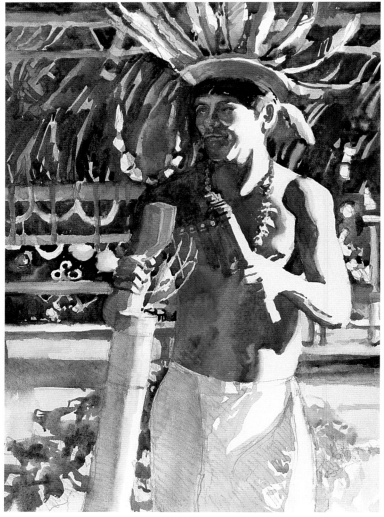

4 Finish the left side of the background dark

Using the no. 2 mop, wet the background area to the left of the figure with clear water so the shapes will blur slightly as you paint them. With the no. 8 round, add heavy strokes of Ultramarine Blue, Transparent Oxide Red and Alizarin Crimson, leaving bright areas of thatched roof showing behind. Blend these shapes together in places so they don't compete too much with the figure. Don't overwork it, though. If it seems too busy, you can calm it down at the end. Paint around the white shapes of the trinkets on the background shelves. Soften some edges so they don't stand out too sharply.

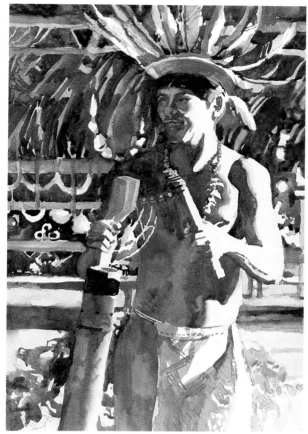

5 Finish the figure

There's a lot of rich color glowing through the loincloth in the evening sun; use a no. 8 round to push it with concentrated Cadmium Orange and New Gamboge for the abstract shapes of the light. The skin tones at this time of day lean toward red, so drop in a wash of Transparent Oxide Red with Cadmium Red and Cadmium Orange while still wet, allowing the colors to blend and granulate with the slope of the board. Subtly indicate the fabric's design. Wash clear water over the cylinder shape, and paint the left edge of it with a stripe of Raw Sienna mixed with Transparent Oxide Red, letting the water carry it to the center. Paint the dark band at the top with Ultramarine Blue and Transparent Oxide Red.

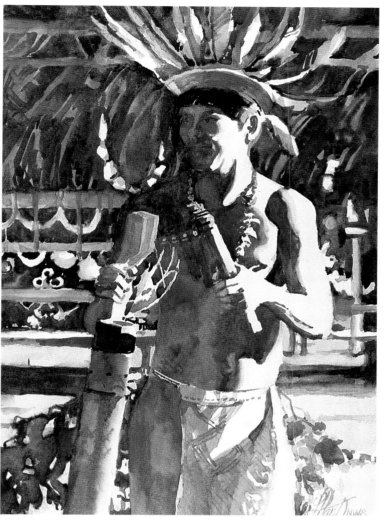

6 Final darks and adjustments

Step back. The design is working well, but some of the background light shapes need to be quieted down a notch in value. Mix a very watery puddle of Manganese Blue, and, using the no. 2 mop, carefully wash it over the ceiling area. Use the same wash to knock back some of the feather tops into shadow. The facial features are a little too prominent also, so do the same thing with a thin wash of Transparent Oxide Red. The foliage area on the left now seems a bit weak too, so rewet it with clear water, and float in a stronger mixture of Transparent Oxide Red and Ultramarine Blue to make a dark neutral green. Paint the left shadow band with this same mixture. Add a few middle values to the bright foliage on the right, and put down your brush. That's it.

AMAZON TRIBESMAN
14" × 11" (36CM × 28CM)

Create multiple contrasts

Materials

PAPER
¼-sheet 140-lb.
(300gsm) hot-pressed

BRUSHES
No. 2 mop
No. 8 round

PIGMENTS
Alizarin Crimson,
Cadmium Red, Man-
ganese Blue, Raw
Sienna, Transparent
Oxide Red, Ultrama-
rine Blue

OTHER
4B or 6B pencil
Kneaded eraser
Masking tape
Paper towels
Spray bottle filled
with distilled water

Strong contrasts will help to compliment and showcase your figures. When you have a figure bathed in strong sunlight (my favorite subject), you have to play the light shapes against a dark background or they will be as lost as a white rabbit in a snowstorm. Paintings that have a full range of lights and darks focus more on value contrast than color, so I often use a muted palette with small patches of bright color. Any time you paint washes in a 9-to-10 value range, they're going to be low-key, subdued colors.

Another thing I like to do in this type of painting is to portray the figure in a representational manner and depict the background as an abstract design.

Value sketch
Sometimes you're lucky enough to nail a really great design in the cropping stage. This value sketch shows a great division-of-space composition working here just the way it is.

Reference photo
The appeal of a figure in sun against a dark background is hard for me to pass up. I was immediately drawn to this elderly woman on the street in Rio de Janeiro. I cropped the photo with my viewfinder to place the focal point (the woman's face and torso) in the upper-right sweet spot of the rectangle.

Drawing
Tape ¼-sheet of paper to your board. With a 4B or 6B pencil, indicate the placement of the figure, and then shade in lightly where the lights and darks belong. Remember that with this smooth paper, the pencil can be easily erased later or it can be covered by dark paint and won't show anyway.

1 First wash: Tone the paper

Using a no. 2 mop, mix some juicy puddles of Alizarin Crimson, Manganese Blue, Raw Sienna and Transparent Oxide Red. Work quickly with big strokes to cover everything that is not in direct light. The value of this wash should be 3 or 4. On the flesh areas, use Transparent Oxide Red alone, but let it blur with the other wash. This whole stage should take no more than a couple minutes. It's not supposed to look good yet. Let dry.

2 Second wash: Paint the face and hair

Use the no. 8 round to paint a dark area behind the left side of the head, using Alizarin Crimson and Ultramarine Blue, washing away the outer edge with clear water. Bring this wet paint into the shadow side of the face and hair and down into the shoulder area in shadow to lose the edge. Come back into the face with Transparent Oxide Red and touches of Ultramarine Blue for the shadows inside her glasses, on the side of her nose, on her upper lip and on her neck area. Wipe out some lights for her nose and glasses frames with a clean, damp brush. Use a touch of Cadmium Red on her ear and cheek. Use some soft strokes of a light mixture of Alizarin Crimson and Ultramarine Blue for the hair in sunlight.

3 Second wash, continued: Complete the figure

With the damp no. 8 round, lift the light out of the arm, legs, neck and fingers in the sun, and blot with a paper towel. This will leave a soft edge where the edges meet on the rounded surfaces of body parts. Using concentrated mixtures of Alizarin Crimson, Ultramarine Blue and Transparent Oxide Red, piece together the abstract dark shapes of the hands, skirt and purse, carrying this wet paint over onto the shadow side of the legs so as not to leave a hard edge. Using this same mixture, paint the dark cast shadows on the bench and underneath it and the shadow under the feet. Pull some of this color into the diagonal shadow in the lower corner, finishing it with a wash of Manganese Blue, leaving some of the original wash showing through as cobblestones. Indicate the shoes with Alizarin Crimson and Ultramarine Blue.

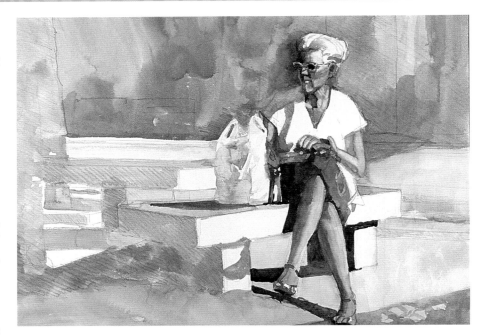

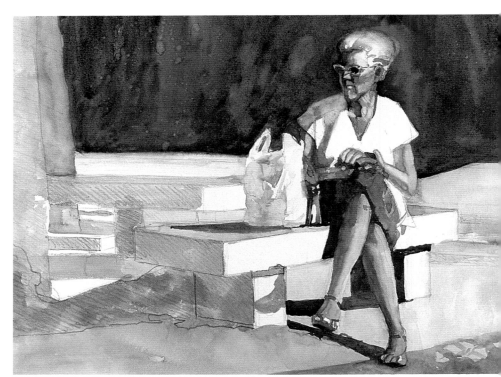

4 Establish the dark background pattern

Continue painting the dark shapes of the background, connecting them together where possible. Use the same color combination as in the previous step, but mix the colors on the paper more than on the palette. Here and there, drop in pure Transparent Oxide Red and Raw Sienna, letting them bleed and run in the dark wash to keep it alive and vibrant. Use hard edges on these abstract geometric shapes to further show off the soft and rounded areas of the figure.

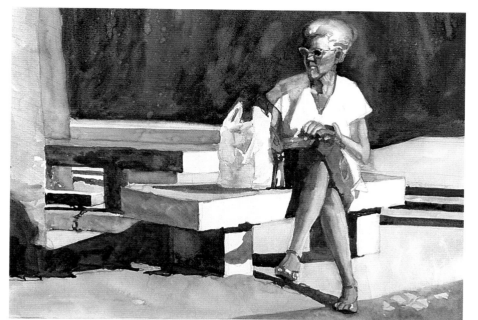

5 Paint the dark shape behind the figure

Wet the area behind the upper part of the figure with the no. 2 mop, coming onto the right side of the hair to create a soft halo in the light. Charge in dark strokes of Ultramarine Blue, Alizarin Crimson, Raw Sienna and Transparent Oxide Red, letting the slope of the board mingle and blend them. Spray some water into this wash while it's wet to create some textural interest. Pull some paint into the shoulder on the left so it leaves a soft edge. Stand back and look at the power this dark shape has in popping the figure forward in space. This is what gives dimension to the focal point.

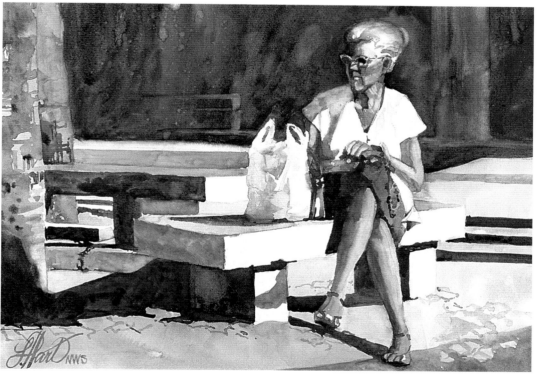

SITTING IN THE SUNLIGHT
11" × 14"
(28CM × 36CM)

6 Final details and adjustments

Since things are so hard-edged in the background, some softer, more diffused detail is needed in the tree trunks to the left. Wet them with clear water, and then add the dark pockmarks in the bark so the edges stay soft. Float in some other color variations and textural interest with light washes of Alizarin Crimson, Manganese Blue and Transparent Oxide Red.

Soften the edge of the dark shadow at the tree base by massaging it with clear water. Pull out with a damp brush a few subtle hints of something going on in the large background shape. Paint behind the stones to add a suggestion of the cobblestone. Just indicate a few in places; the viewer will fill in the rest. Step back, and look at the whole thing from a distance. When there's nothing else to add that will make an improvement, you're finished.

Use an unusual pose to add interest

Sometimes unexpected poses lead to good compositions. When I asked my daughter Brittney to pose for some photos on our deck, the best shot came between poses, when she was just resting. Capturing people in candid moments like this places a natural, spontaneous feeling into the painting. The unusual angle of the face, the light patterns on the head and the feet, the flowers dividing the figure in half and the symmetry of the design added up to an unusual and different composition for a figure painting. It pays to look at things from a different angle.

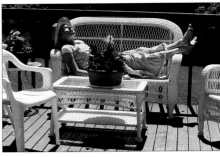

Reference photo
I cropped the photo so the focal area—the face and torso—falls in the upper-left quadrant.

Drawing
Tape a ¼-sheet of paper to your board, and draw the figure, hatching in the shading to indicate where the dark values will be.

1 First wash: Create a colorful underwash with a high-key triad

Start with a clean palette and freshly stirred, sprayed pigments. Using a no. 2 mop, mix three watery puddles of Alizarin Crimson, Manganese Blue and Aureolin. Allow them to mingle, not mix, on the palette. Starting on dry paper with your board tilted, put a flat, colorful wash of one value (3 or 4), leaving the light areas as white paper. Purples, greens and oranges should create themselves. Slop this wash on quickly, and add a little Cadmium Red in the flowers and skin tones. Let dry.

2 Second wash: Establish the focal point

Use the no. 8 round for the rest of the painting. Starting in the upper-left corner, paint some bright patches of foliage with a mixture of Manganese Blue and Aureolin. While this is still wet, charge in some Ultramarine Blue and Transparent Oxide Red for the dark foliage. Add the fence rail with a dark mixture of Transparent Oxide Red, Alizarin Crimson and Ultramarine Blue, painting behind the hat brim. While this is wet, paint the hat with a mixture of Aureolin, Manganese Blue and a touch of Alizarin Crimson, leaving white shapes for the holes where the sun is coming through. Let the hat soften against the wet edge of the background. While the hat is still wet, begin the face with mixtures of Cadmium Red, Alizarin Crimson, Manganese Blue and Aureolin. Soften edges as you work. While the paper is still damp, add the dark shape of the hair with Transparent Oxide Red, Ultramarine Blue and Alizarin Crimson. Pull shadows out of the wet paint onto the arm of the love seat, and add pure Manganese Blue.

3 Paint the love seat back and the flowers

Paint the dark behind the wicker love seat: Wet the area first, and float in Alizarin Crimson, Ultramarine Blue, Transparent Oxide Red and touches of Aureolin.

Leave some indications of the woven wicker near the flowers, and allow a hard edge at the shoulder and skirt. Paint the top flowers in pure Aureolin and Cadmium Red, letting them bleed into the dark chair back. Paint the dark greenery with Ultramarine Blue and Transparent Oxide Red combinations. Leave plenty of small white shapes for sparkle so the flowers don't smother. Pull the dark color directly into the flowerpot lip, carefully preserving the sunlit spots and adding more Transparent Oxide Red and some Cadmium Red for the terra-cotta pot. Link this color into the arm so it joins the two shapes together. Pull the cast shadow out of the pot while it's still wet so as not to leave a hard edge there.

4 Paint the feet and the right side of the background

In the top right corner, paint the foliage as you did in step 3, jumping over the white strip of the top of the rail. Paint the rail in a warm dark of Transparent Oxide Red, Alizarin Crimson and Ultramarine Blue. Carry this down behind the feet. Paint the feet with Cadmium Red and Manganese Blue for the shadows, leaving white paper for the light areas. Soften the edges of the legs and feet with a damp brush. Paint the railing rungs with the dark background mixture, coming onto the deck floor with their cast shadows. While the rungs are wet, paint the bright grass behind them with Aureolin and Manganese Blue, letting their edges blur. Wipe out with a damp brush some indications of the railing rungs in the dark shape below the feet.

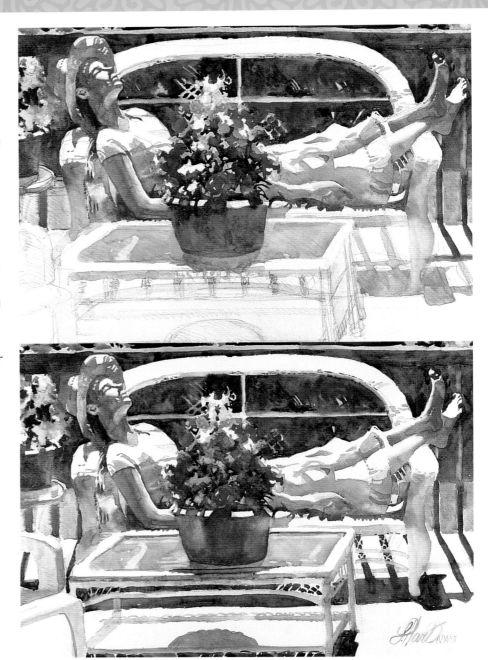

5 Paint the left background, and finish the figure

Wet the area on the left with clear water, and drop in pure color for the flowers so they stay out of focus. Paint the dark shapes of the foliage with Ultramarine Blue and Transparent Oxide Red, continuing down into the flowerpot and the dark space behind the chair arm. Add some Cadmium Red to the sunny side of the flower container, pulling the cast shadow at the bottom out of the wet color. Paint the table edge in Manganese Blue, observing the sunlight. Paint the dark railing rungs and the bright strip of green grass as in step 4. Pick up some Manganese Blue for the shadows under the chair arm behind the model. Add touches of Ultramarine Blue under the elbow and forearm to anchor them to the chair. Wet the shadow area of the dress bodice, and darken the shadow here as well, lifting out some indication of wrinkles. Darken the shadow areas of the skirt fabric on the right side, using Ultramarine Blue and Alizarin Crimson. Paint a dark shadow under the skirt, and continue it up the side of the chair arm.

6 Finish the foreground, and add final details and adjustments

Paint the arm and leg of the chair in the lower-left corner with Manganese Blue, Ultramarine Blue and Alizarin Crimson. Move to the dark shape under the love seat, and paint it in a dark Ultramarine Blue, Alizarin Crimson and Transparent Oxide Red, carrying it behind the foreground table. Paint the hint of the dark shape under the table with the same mixture, leaving the wicker webbing showing here and there. Paint the table legs with Manganese Blue, adding a little Alizarin Crimson for the round shadow cast by the pot above. Add cast shadows for the far left deck railings. Lift some color off the front flowerpot with a damp brush, and blot with paper towel. Brush some clear water over the foliage of the bouquet to knock back some of the white space. Pull out a few more reflections on the glass tabletop with a damp brush, and step back.

SOAKING UP THE SUN
11" × 14" (28CM × 36CM)

Shedding light on the main subject

Chapter Seven Summary

- In a painting in which the figure is the main subject, the focal point should be the head and torso.

- Create dimensional form at the focal point.

- Hard edges on the figure will make it appear to come forward in the picture plane.

- Carve out light shapes by painting a dark value behind them.

- Exaggerate the color of flesh-tones on figures in sunlight.

- Placing a realistic figure on an abstract background will compliment the figure.

- When there's nothing left to do to improve a painting, it's time to quit.

- Candid poses can add freshness and spontaneity.

Although this chapter's title is "People as the Main Subject," people are not really the main subject of this chapter. The real subject is light, particularly the way it illuminates the figure, revealing fluid form and enhancing warm fleshtones. Light gives life to everything it touches and makes whatever it falls on more beautiful. It is, by itself, a master artist, and is truly the force that guides my brush. A figure without a strong light source is like a room without air. You have to have it to breathe life into the people you paint.

In this painting the two boys are unquestionably the main subject, but the strong light source enhances their rosy complexions and describes the form of their features. The left boy's face comes forward in space where the dark, abstract reflection of trees in the water cuts behind it, leaving a sharp outlined edge. In the shorter figure, the opposite is true—the dark hair is framed by the white cloud reflection, making him appear to pop out in space by contrast. The diffused, abstract background shapes contrast nicely with the sharp, in-focus figures, making the subject the main attraction to the eye.

TUCK AND WES
11" × 14" (28CM × 36CM)

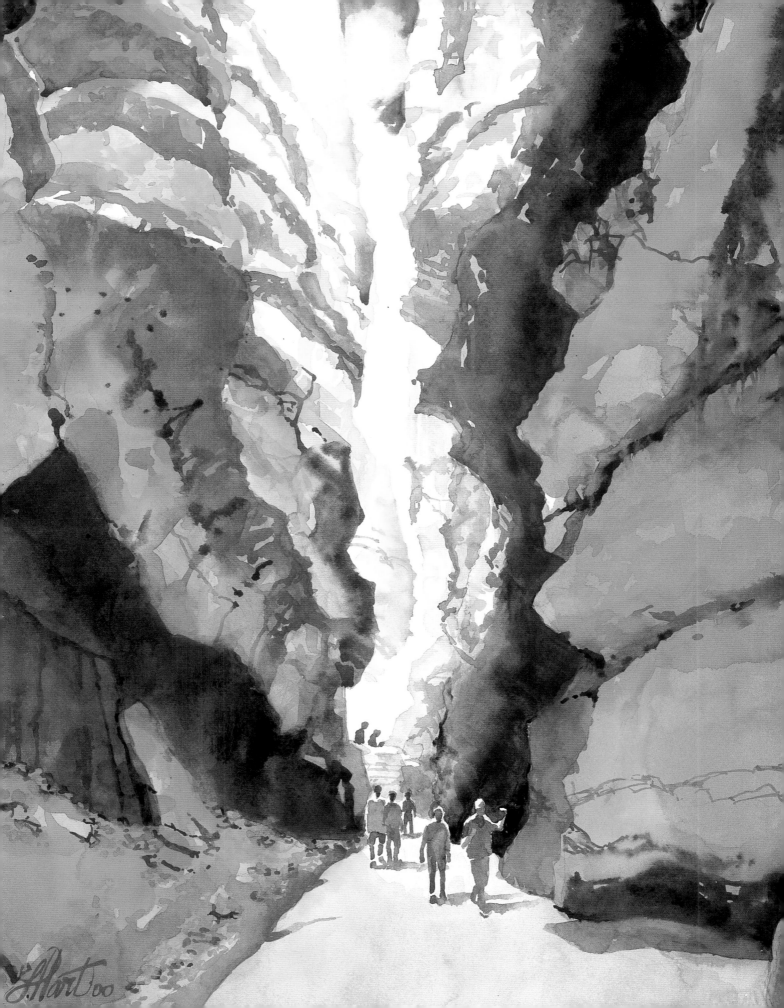

Putting People in an Environment

Figures impart life, giving the viewer of a painting something to identify with.

—TED GOERSCHNER

Just like human interest stories can draw our attention in the newspaper, adding human interest to an environment can enliven our paintings if the figures are well placed and well proportioned. Figures in landscapes, cityscapes and interiors can serve several positive purposes. They can:

- Show scale by allowing us to compare a familiar size to an unknown size;

- Add a counterbalance, portraying a small shape against a large shape;

- Add a bright spot of contrasting color to what might otherwise be a monochromatic color scheme;

- Add human interest to attract the viewer's attention to a certain part of the painting;

- Add action or movement to a scene.

All that's necessary to paint a believable person seen from a distance is an accurate depiction of the figure's proportions and gestures, which are sometimes best captured in a few simple strokes of color. The simpler and more abstractly these incidental figures are rendered, the more natural and believable they will look.

In this painting, the incidental figures add excitement by their gesture of upward admiration. The size of the sandstone walls is exaggerated by the tiny figures in comparison.

WALL STREET, BRYCE CANYON
20" × 14" (51CM × 36CM)

Demonstration

Putting people in a landscape

Materials

PAPER
¼-sheet 140-lb.
(300gsm) hot-pressed

BRUSHES
No. 2 mop
No. 8 round

PIGMENTS
Alizarin Crimson,
Aureolin, Cadmium
Red, Manganese
Blue, Transparent
Oxide Red, Ultrama-
rine Blue

OTHER
4B or 6B pencil
Kneaded eraser

Even though the subject matter varies greatly between landscapes, cityscapes and interior settings, the initial approach to each is the same: Begin with a light-value wash that unifies the design, and cover everything but the areas that are in light.

In painting landscapes, think about the fact that figures will command attention wherever they are placed in the painting, so don't put them somewhere you don't want your viewer's eye to go. Remember, they will also act as reference points to show the scale of nearby things such as trees or rocks, so depict believable proportions. Take the liberty to let figures in landscapes add a touch of bright color when the color scheme may be monochromatic.

Reference photo

Value sketch
Create a loose value sketch, indicating the pattern of the lights and darks.

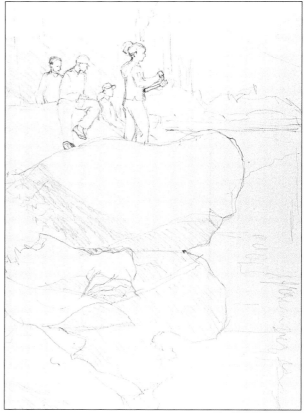
Drawing
Keep the drawing simple; just indicate the placement of the figures and the main shapes of the rocks and reflections. There is a lot of leeway in drawing landscapes because trees and rocks don't have to be exact. The figures do need to read as figures however, so spend some time getting their proportions and gestures right.

1 First wash

Make three watery puddles of a high-key triad of Alizarin Crimson, Aureolin and Manganese Blue. Don't blend them on the palette. Starting on dry paper at a slant, apply a very loose wash using a no. 2 mop. Let the colors merge and flow on the paper, leaving the white areas untouched. Take the color directly through the figures to integrate them into the painting. Don't worry if this wash looks uneven; you'll cover up a lot of it later. Keep it soft and fluid. Leave no hard edges, and stay in the 3-to-4 value range. Let this dry completely.

2 Second wash: Figures and background trees

Use a no. 8 round for the remainder of the painting. Mix the low-key triad puddles for the second wash, using Alizarin Crimson, Transparent Oxide Red (this is the yellow) and Ultramarine Blue. You'll also need some Cadmium Red for the figures' fleshtones. Wet the background area, and drop in a tree color using a mixture of Ultramarine Blue, Transparent Oxide Red and a little Aureolin in places. Paint behind some of the tree trunks, allowing some of the original wash to show through. Paint the figures' faces with Cadmium Red and the torsos with mixtures of the second-wash triad colors, letting them merge and blend into the background. Leave a little negative space to represent the fishing-pole handle.

3 Second wash, continued: Lower rock and reflections

Wet the rocks with clear water, and float in darker mixtures of the same triad you used in step 2, adding some of the Aureolin again for the bright moss and water reflections. The shadow area and reflection directly underneath the rock is nearly full-strength from the tube because it's going on a wet surface and will dilute as it meets the wet paper. Remember, the rule in the second wash is more pigment, less water. Paint around the dead tree in the water as well as the foliage on the left edge of the painting. Leave a crisp edge on the darkest reflection of the big rock.

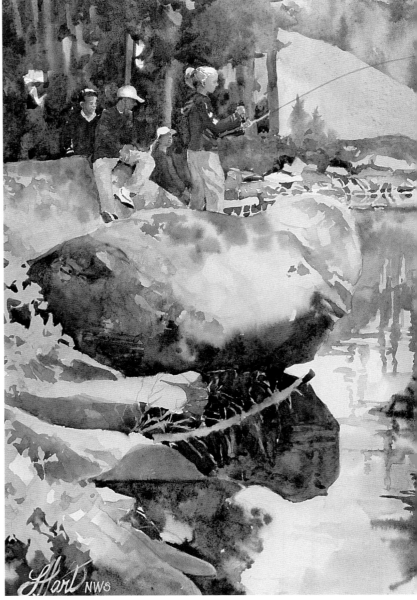

4 Water reflections and far lake edge

Wet the water area to the right of the rocks with clear water, and float in the tree reflections with the same colors, still using your no. 8 round. Pull some of this paint downward, and zigzag through it to make ripples in the water. Preserve the beautiful white area where the sky reflects in the water. At the far bank of the lake, paint behind the logs at the water's edge with Ultramarine Blue and Aureolin, making their reflections in the water a mirror image.

5 Final darks and details

Finish painting the seated man's pant legs and shoes, and finish the girl's fishing pole.

Add a few more darks to the background foliage and a little more of a midvalue green to the foliage in the left foreground. The large rocks can use a little more moss and texture at the tops, but wet the area first so the edges will be diffused. Stand back, and see how you did. Do you see how using a high-key underpainting at the beginning unifies the whole color scheme of the painting?

FISHING AT BIG SANDY LAKE
14" X 11" (36CM X 28CM)

Putting people in a cityscape

PAPER
¼-sheet 140-lb.
(300gsm) hot-pressed

BRUSHES
No. 2 mop
No. 8 round

PIGMENTS
Alizarin Crimson,
Aureolin, Manganese
Blue, Transparent
Oxide Red, Ultramarine Blue

OTHER
4B or 6B pencil
Kneaded eraser

Cityscapes and street scenes can be challenging to paint because they are usually bustling with the activity of crowds of people. It can seem overwhelming to think of painting each person individually, but if you treat the group as one shape and learn to paint people as simple silhouettes, it greatly simplifies this complicated task.

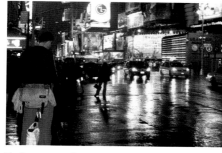

Reference photo
Times Square in New York City in the rain at night is a spectacular sight!

Value sketch
The value sketch indicates the placement of the light and dark values. Getting your darks correct here will help you end up with spectacularly glowing lights at the end.

Drawing
Block in the placement for the figures, the cars and the reflected lights on the pavement.

1 First Wash
Wet the paper with a no. 2 mop. When the sheen leaves, charge in a high-key wash of Alizarin Crimson, Aureolin, Manganese Blue and a little Ultramarine Blue. Allow the colors to bleed. Keep the edges soft. Leave plenty of white for the lights. Allow to dry.

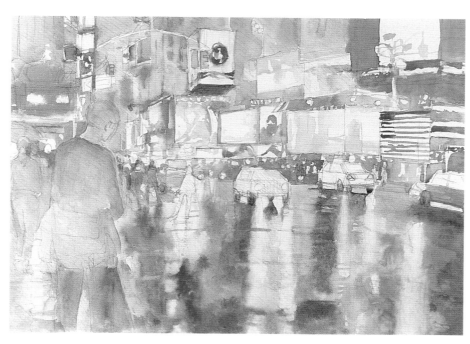

2 Second wash: left background and foreground figure

Use a no. 8 round for steps 2 through 4. Mix three separate puddles of Alizarin Crimson, Transparent Oxide Red and Ultramarine Blue. Let them touch but not mix. Begin at the top, adding the dark patches of sky and distant buildings with various mixtures of the triad. Paint around light shapes as you work your way down. Keep the values on the second half of the value scale. Let the shapes of the foreground figures melt and bleed into one another, fitting together as if they were puzzle pieces.

3 Second wash, continued: middle ground

Paint the dark shadow areas under the marquees with a very concentrated mixture of the same low-key triad used in step 2. Create groups of people by painting around them and leaving them as negative shapes against the dark background or as dark silhouettes against a light area. The middle figures standing in the street should be hard-edged silhouettes that stand out against the bright lights and pavement reflections, so paint them on dry paper. Wet the area below them to paint their softer-edged cast shadows. Paint the cars, making sure to capture the reflected lights, and pull the wet paint of the wheels directly into the cast shadows to connect them to the pavement.

Painting detail, capturing gesture

Notice how this figure is simply a flat silhouette of one color and one value. Because the gesture is captured correctly, with the slant of the hips tilting in the opposite direction of the shoulders, it clearly reads to the eye as a woman leaning out into the street to watch for someone coming. We often make things more complicated than they need to be.

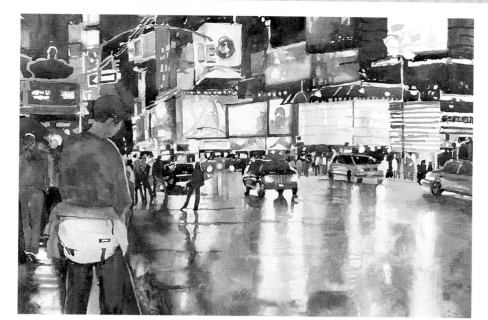

4 Complete the upper building

Paint the upper part of the buildings using combinations of the same low-key triad. Soften edges in some places, but leave sharper edges around the bright lights. Leave lots of little white spaces for sparkle.

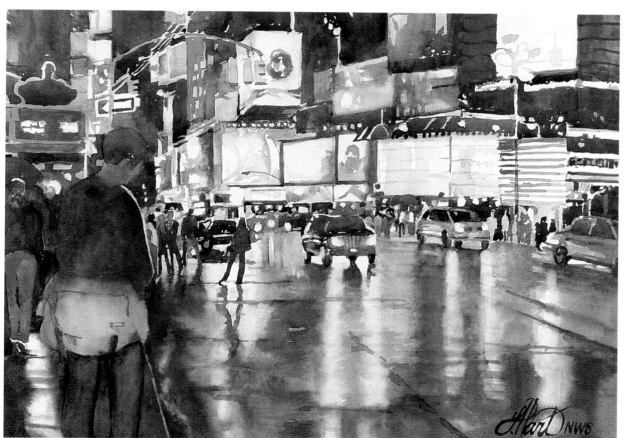

5 Add final darks, and make adjustments

Wet the foreground pavement with the no. 2 mop, and float in some more darks to strengthen the value of the foreground and create a stronger contrast between it and the light reflections. Pull out more lights under the cars with a damp brush. Add a few more cracks and details in the pavement.

You're finished! You should be able to see the soft glow of the night lights reflecting on the street.

TIMES SQUARE
11" × 14"
(28CM × 36CM)

Painting people in an interior setting

Painting figures in an interior setting can be more of a challenge than painting figures in natural sunlight because you don't always have a strong direct light source. The light inside can come from several different sources, making it hard to see a well-defined light-and-shadow pattern on the figures. Another problem indoors can be dim lighting. The typical response is to use a flash to take pictures, but doing so usually wipes out the shadow pattern altogether. Try to avoid using a flash for interior settings, and you will usually wind up with photos that have an extra-warm cast to them but a good light-and-shadow pattern. Some of the unique lighting conditions you get indoors can lead to extra-moody, low-key paintings.

Reference photo
This is an intriguing subject to paint because of the stark band of foreground figures against the light marble pillars and stairways.

Drawing
Lightly indicate the perspective of the building's walls and hallways, and establish proper proportions of the figures in relation to doorways, furniture, etc. For example, the figures on the landing need to be small enough to fit through the doorway behind them.

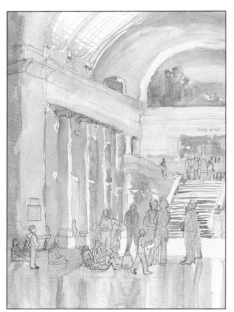

1 First wash
Mix a muted combination of Transparent Oxide Red, Manganese Blue and Quinacridone Gold, and add a little Yellow Ochre. Using a no. 2 mop, mix separate puddles of the paints, letting their edges mingle. Working on dry paper, quickly and loosely cover everything but the whites. Do not go darker than a value 5. Paint directly through the figures. Use Quinacridone Gold alone for the warm light being cast in the area behind the pillars. Let this stage dry before going on.

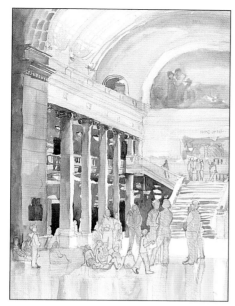

2 Second wash

Switch to the no. 8 round for the rest of the painting. Change the blue in the triad to Ultramarine Blue to get some darker values. Start with a light wash of Ultramarine Blue and Transparent Oxide Red for the brick column on the left. Indicate a little detail of the brickwork while the paint is still wet. Paint the darker values behind the columns, leaving some of the background figures as negative space silhouettes. Allow the first wash to show through as foreground for the light columns. Paint around the figures, carving out their upper torsos as negative shapes.

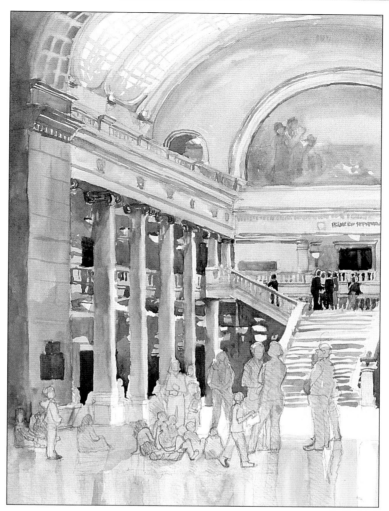

3 Second wash, continued

Use the low-key triad of Ultramarine Blue, Transparent Oxide Red and Quinacridone Gold to continue painting the background area above the stairs and the small grouping of people on the landing. Add the detail work in the plaster above the columns, and cut in a dark value behind the stairway banister on the far right. Also add the group of people on the stairway landing (see close-up).

Painting detail: The background group of people

To add the group of figures on the landing, paint them as a collection of abstract blobs of paint using concentrated mixtures of Ultramarine Blue, Transparent Oxide Red and a touch of Cadmium Red Medium for the bright shirt. From a distance the brain will interpret these as people.

Be sure to preserve the effect of the light on the tops of their heads and shoulders as white paper so that it looks like the overhead lights are reflecting on their shoulders and hair.

4 Add foreground figures and reflections

Paint the foreground figures using the pull-down technique (page 71) and Cadmium Red mixed with Quinacridone Gold for the fleshtones. While the paint is still wet, touch back into the bottoms of the figures with the darks for the reflections, and pull this paint down, softening the edges with a damp brush. These figures should be a very dark value to make them appear to come forward in the picture plane.

5 Add final darks, and make adjustments

Paint the shadow side of the column bases with a light wash of Manganese Blue mixed with Transparent Oxide Red. Brush a little of this over the silhouettes of the figures directly behind the columns as well. Stand back. Did you achieve a warm, indoor glow? If not, re-wet some of the warm, yellow areas of the painting. While that is damp, float in more concentrated Quinacridone Gold to strengthen the yellow cast of indoor lighting.

FIELD TRIP TO THE CAPITOL
14" × 11" (36CM × 28CM)

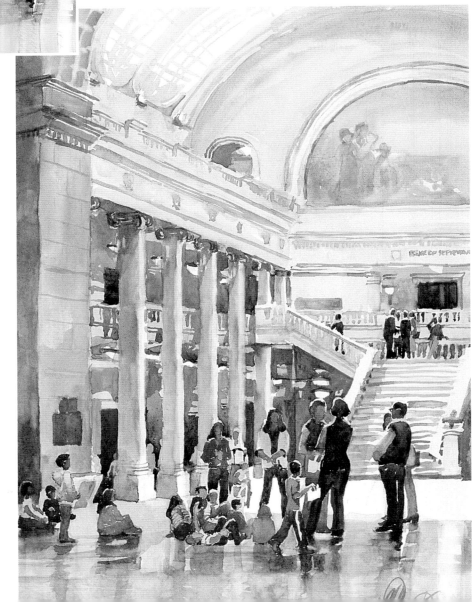

Paint what you see, not what you know

Chapter Eight Summary

- A high-key underpainting can unify your whole composition.

- Adding human interest can enliven paintings by adding life, color and movement.

- Treat crowds and groups of people as one shape instead of trying to paint each individual.

- It doesn't require years of studying human anatomy to be able to believably render incidental figures.

- All that's necessary to accurately paint figures seen at a distance is to get the shape, proportion and gestures right.

I used to think it was hopeless to expect to portray people in paintings without first paying my dues in years of life drawing and anatomy classes. While I'm certainly not discounting the value of understanding human anatomy, it is also just as important to simply train yourself to paint what you see. Learning to correctly copy the light and shadow patterns of the figure as your eye sees them, and not as your intellect tells you to paint them, is more crucial. The best art education is to be had not in books but in the application of paint to paper.

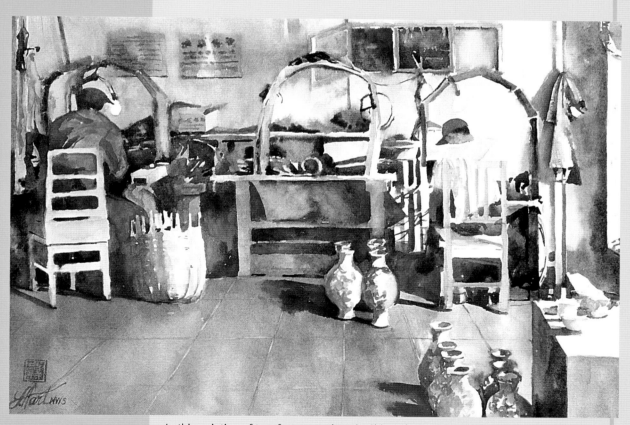

In this painting of two factory workers in China, the strongest light source is coming from the window on the far right, creating a brightness of mood to an otherwise dismal work space. Using a bright red for the hat of the figure in the light also draws attention to this focal area. The placement of the figures' backs to the viewer creates a curiosity about what it is they're so intently working on.

MADE IN CHINA
14" × 20" (36CM × 51CM)

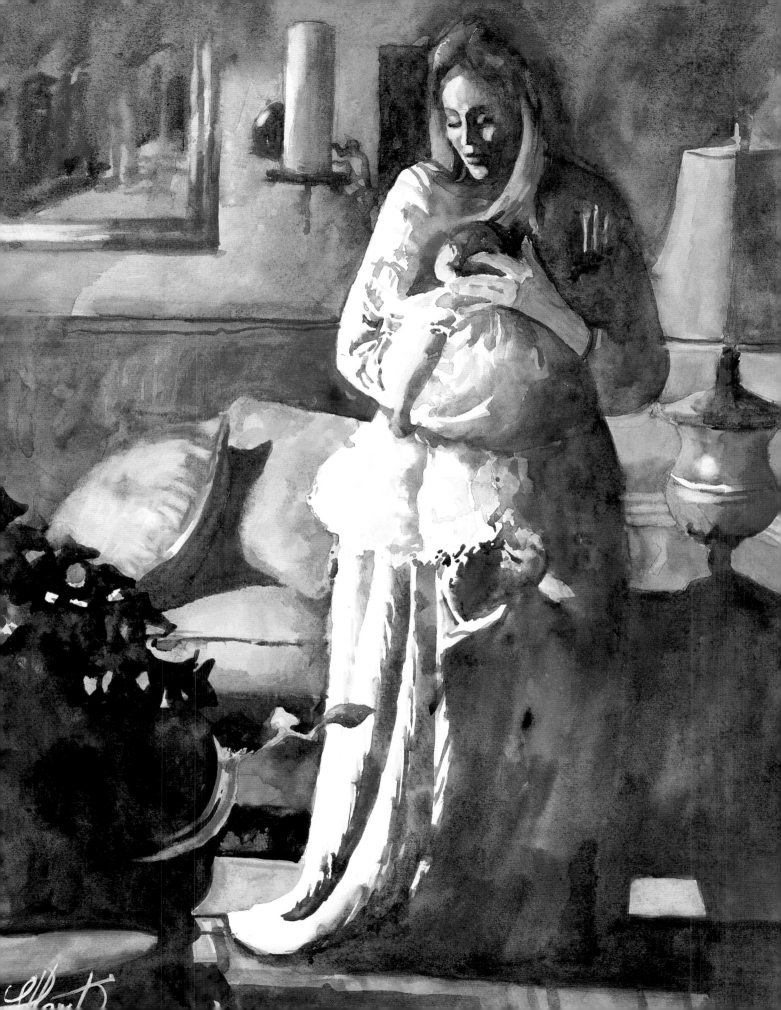

Painting the People You Love in Watercolor

Art embalms time and rescues it from its proper corruption.

—A.D. COLEMAN

One of the universal desires we share as human beings, I think, is wanting to leave something of ourselves behind when we leave this life. There are many different ways people have found to immortalize themselves, such as keeping journals, writing books, sewing quilts, planting orchards and gardens, making films, building structures, even freezing their DNA. As artists we preserve ourselves through our paintings. Inherent in us is the desire to let those who come after us know who we were, what we cared about and what stirred our passions as members of the human family. In this chapter we'll talk about a few ways to do this successfully.

There is a moment in motherhood when there is no division between morning and night—a moment suspended between time and eternity, when earth and heaven briefly meet. I have known this moment. I wanted this painting of my daughter-in-law and my first grandchild to capture this feeling shared only by a new mother and her baby.

IN HER MOTHER'S ARMS
20" × 14" (51CM × 36CM)
COLLECTION OF BRODY AND CORINE HART, MICHIGAN

Painting people from old photographs

Materials

PAPER
¼-sheet 140-lb.
(300gsm) hot-pressed

BRUSHES
No. 2 mop
No. 8 round

PIGMENTS
Burnt Umber,
Cadmium Red,
Manganese Blue,
Transparent Oxide
Red, Transparent
Oxide Yellow

OTHER
4B or 6B pencil
Kneaded eraser
Masking tape

When we put faces to forbears' names, they become real people, and we gain a sense of belonging when we link ourselves to them by painting from old photographs. Old photographs are almost always black and white, so they offer you the choice of painting with arbitrary colors. Remember, as long as you get the values right, you can use whatever colors you want, and the painting will still work. I like to use a warmer, more muted palette for these paintings to give the feeling of the sepia tones of old photos.

Reference photo

With family photos, you may not own the original and will have to get a copy made. Most copy stores will reproduce and even enlarge photos for you.

As a young girl I spent every Sunday night in the backyard of this house. Grandma served her homemade ice cream outside on the patio, while the scent of Grandpa's prizewinning roses drifted to us from the surrounding flower beds. An indescribable feeling wells up when I put my brush to the faces of loved ones who have passed on, as if they're really not that far away at all.

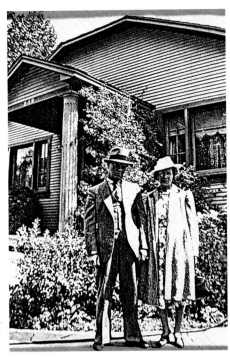

Value sketch

Make a quick rough sketch of the value pattern to ensure you have a strong design.

Drawing

After you tape your paper to a board, draw the subjects and indicate the shaded areas. Concentrate on linking darks and opening up white areas into each other where you can.

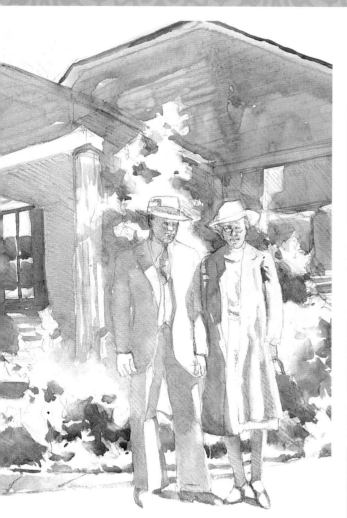

Paint Around White Shapes

I don't like using masking fluid to preserve white shapes; instead, I prefer to paint around them. Here are a few reasons why:

- I think masking fluid leaves a mechanical, forced look with edges that are too hard.

- No matter how hard I try to plan, masking fluid never ends up in the right place.

- I often leave so much white in my paintings, I'd spend all day masking out, and I'm not that patient.

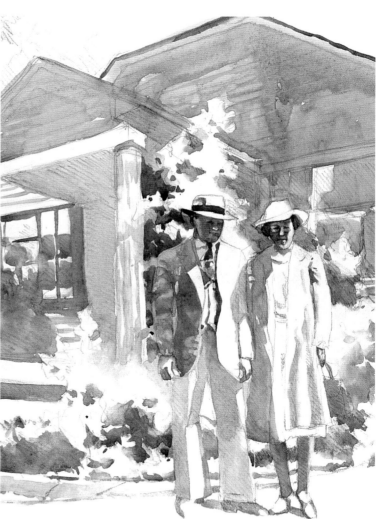

1 Apply the first wash

Using the no. 2 mop, mix separate watery pools of Manganese Blue and Transparent Oxide Yellow, letting the edges mingle. Beginning with dry paper, pick up a full brushload of color, and start at the top of the house, pulling the bead of paint down. Each time you pick up a new load of pigment from the palette, vary the color temperature from warm to cool by using more Transparent Oxide Yellow (warm), and then more Manganese Blue (cool). Touch back with fresh color into the bead where you left off, and carry this right through the figures. Don't let the values get any darker than 4 or 5. Paint around the areas where the light is hitting. Soften some of the edges of the bushes by touching back into them with a damp brush. Let dry.

2 Begin painting the face and clothing

Switch to the no. 8 round for the rest of the painting, and begin working on the faces with a mixture of Cadmium Red, Transparent Oxide Red and Transparent Oxide Yellow, leaving a sharp edge for the white hat brims. Pull out some lights in the faces when dry with a clean, damp brush. Begin adding some of the darker values behind the figures to bring them forward.

3 Add the dark values to the figures

Using concentrated Manganese Blue, paint the shadow patterns on the man's suit and shoes, being careful to preserve the white highlights. Follow the same technique to paint the shadow pattern on the woman, using a warmer mixture of Manganese Blue and Transparent Oxide Yellow.

4 Complete the final dark pattern in the foliage and house

The final dark patterns will bring the figures forward. Mix some strong pools of Burnt Umber, Transparent Oxide Yellow and Manganese Blue, and paint the shadow areas of the bushes and window reflections. Paint the underside of the porch roof, warming it by dropping in a touch of pure Transparent Oxide Red. Add the shadows under the rooflines, and indicate the wood siding with a few lines. Don't paint all the lines; the viewer's eye will fill in what isn't there. Wet the area behind the house, and let the tree behind it bleed gently into the background sky. Finish by painting a dark shadow to indicate the garden hose.

Stand back. Do you see the overall pattern before you see the parts? The abstract design should be the primary attraction, with the subject matter, or story, being secondary.

EFFIE AND ELMER
14" × 11" (36CM × 28CM)

Freezing the moment in your paintings

PAPER
¼-sheet of 140-lb.
(300gsm) hot-pressed

BRUSHES
No. 2 mop
No. 8 round

PIGMENTS
Burnt Umber, Manganese Blue, Raw Sienna, Transparent Oxide Red (or Burnt Sienna), Ultramarine Blue

OTHER
4B or 6B pencil
Kneaded eraser
Masking tape
Paper towel

Art can transport us to hidden treasures of the heart's favorite memories. Every year my extended family spends a week in Newport Beach, California. Sometimes we have upwards of fifty family members together. It's a time for us to bond and forget about routine time commitments for a few days. This painting of my daughter Brooke (center) and my nieces and nephew freezes my mind's image of them as children (they're all adults now) leaping for the sheer joy of just being together.

One of the advantages to painting from photographs is the fact that you can have figures in action poses that would be impossible to paint from life. In this demonstration you'll learn to paint figures that are captured leaping in midair.

Reference photo
I cropped the photo at the top to make the figures come forward in the rectangle. Sometimes if the figures are too small for the format, the overall design will lose its strength.

Drawing
Tape the paper to a board, using regular masking tape. Lightly outline the shapes of the whites of the waves and water area. Sketch the figures, and indicate the shadow areas with shading.

1 First wash: Paint the distant water
Begin on dry paper. Using the no. 2 mop loaded with water, mix one juicy pool of Manganese Blue and one of Raw Sienna, letting the edges mingle slightly. Pick up a load of the Manganese Blue puddle, and quickly paint in the shape of the background ocean, preserving the white wave and plenty of white highlights for sparkle in the water. Touch the wave's edge with a rinsed, thirsty brush to soften it in places. Blot with a paper towel.

2 First wash: Complete the foreground water and beach area

Still using the no. 2 mop, paint the rest of the water and beach area in one continuous wash, using mixtures of the same colors, only using more Raw Sienna than Manganese Blue as the water warms near the beach. Leave white paper for the sunstruck areas of the figures and the whitecaps. While still wet, add some cast shadows of the figures and the foreground reflections with short, choppy strokes of concentrated mixtures of Burnt Umber, Ultramarine Blue, Transparent Oxide Red and Raw Sienna. These edges should softly bleed on the paper. Let this phase dry. It shouldn't look like much yet.

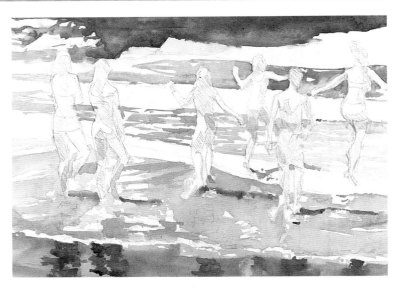

A: *Pick up a load of Raw Sienna and Burnt Umber. Starting at the top of the figure, pull the mixture down, leaving white spaces for the sun's reflection on the hair.*

B: *Rinse the brush and pick up a load of Transparent Oxide Red for the skin tones. Touch this into the lower edge of the paint you just put down. Let the two areas blend and merge downward.*

C: *Pick up a dark mix of Ultramarine Blue for the swimsuit in shadow, painting around the light areas in sun.*

3 Paint the center figure (detail progression a through d)

Switch to the no. 8 round, and mix some separate pools of Transparent Oxide Red, Burnt Umber, Raw Sienna and Ultramarine Blue on the palette. Paint the center figure following the steps listed above and using the pull-down technique (page 71).

D: *Keep merging these color patches until you get to the bottom of the figure.*

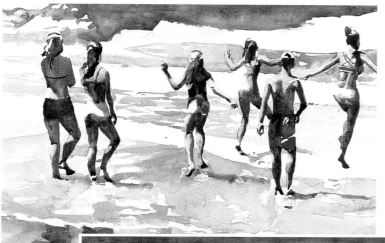

4 Complete the remaining figures

Paint the rest of the figures using the same pull-down technique. Try not to go back in, except to soften some edges between light and shadow on the figures' skin. Your goal is to portray each figure as a collection of abstract shapes of light and shadow. Step back. Do you see how real each figure looks from a short distance?

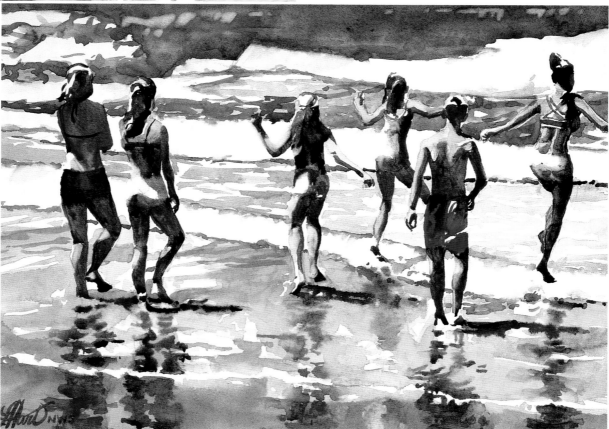

5 Finish the figures' reflections, and add final darks and details

Using the no. 2 mop, rewet the area just beneath the figures with clear water. When the sheen just leaves the paper, switch to the no. 8 round, and paint the figures' reflections with choppy strokes of the same colors you used to paint the figures. (Reflections come straight toward the viewer, while cast shadows indicate the angle of the sun's rays.) Allow the edges of these shapes to softly bleed. Exaggerate the color, since you're working on wet paper. Add a few darker, choppy strokes to indicate waves on the water. Define the wave further by painting a darker border along the top and bottom edges, pulling the paint into the wave interior here and there to indicate churning water. Pull out a few more lights in the distant wave with a clean, damp no. 8 round, and blot the area with a paper towel.

WHERE TIME STANDS STILL
11" × 14" (28CM × 36CM)

Put the people you love in your paintings

Materials

PAPER
¼-sheet 140-lb.
(300gsm) hot-pressed

BRUSHES
No. 2 mop
No. 8 round

PIGMENTS
Alizarin Crimson,
Cadmium Red,
Manganese Blue,
Transparent Oxide
Red, Ultramarine
Blue, Yellow Ochre

OTHER
4B or 6B pencil
Art board
Kneaded eraser
Masking tape
Paper towels

Family members are my favorite subjects to paint because I feel most passionate about them and most comfortable painting them. I can close my eyes and see my daughters' profiles in my mind. When you have this kind of love and familiarity for your subject, it will come across to the viewer.

My daughter's bridal pictures were taken outdoors on a cold but sunny fall day. I went along to help her with the dress and managed to snap a few shots of my own as I followed her and the photographer around. There are few moments that etch themselves as indelibly into one's mind as a daughter in her wedding gown standing in sunlight.

Reference photo
I quickly snapped this shot in between formal poses during my daughter's bridal portrait session. I loved the way the sunlight hit her back as she was turning and how the dress's train caught the sun as the photographer lifted it.

Value sketch
Make a quick thumbnail sketch of the light and dark value patterns. There's no improving on this geometric, division-of-space design, in which the light patterns on the steps lead the eye directly up into the center of focus, which is the bride's sunlit back. The placement of the focal point is in the upper-left sweet spot.

Drawing
Tape a ¼-sheet of paper to your board with masking tape. With a 4B or 6B pencil, sketch the subject onto the paper, lightly hatching in the shadow areas.

1 Apply the first wash

Using the no. 2 mop, mix three separate puddles of Alizarin Crimson, Manganese Blue and Transparent Oxide Red on your palette, letting them mingle. Quickly cover all areas of the subject that are not in sunlight; use loose, wet mixtures, not going any darker than a value 5. Allow this to dry completely before moving on. This first wash has already done half the work.

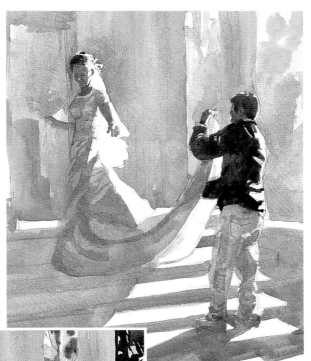

2 Establish the figures

Mix Ultramarine Blue and Transparent Oxide Red with a no. 8 round. Using the pull-down technique, start at the top of the bride's hair, leaving as white paper the right side of the hair in sun. Mix a rich fleshtone color with Cadmium Red and Yellow Ochre, and touch this into the damp edge of the hairline. Continue this mixture on the arms and the fingers of the hand on the right. Touch a little Manganese Blue into the damp face for the eyelashes and shadows under the chin. Use the pull-down technique for the photographer's hair and jacket with Ultramarine Blue and Transparent Oxide Red. Leave as white paper the shape of his jacket where the sun hits. Paint his face with Cadmium Red, and let it bleed into his hair. Use this same paint on his hand. Using the lighter tones of the first-wash triad, paint the pattern of his pants. Paint the folds of the dress with a midvalue of the first-wash colors, softening some of the edges with a damp brush.

3 Second wash: Paint the background

Mix puddles of Alizarin Crimson, Transparent Oxide Red and Ultramarine Blue in greater concentrations. Fill a no. 8 round with clean water, and wet the areas of background foliage and the door to the left of the bride. Drop these concentrated colors onto the wet paper, and let them blend without mixing. Leave some lighter areas to indicate sky showing through the leaves and the detail of the stained glass in the door. You may have to lift out some of these light areas with a clean, damp brush. When the door has dried, carefully brush a light wash of Manganese Blue over it to soften the glass reflection a little.

4 Add the foreground shadows

Using the same second-wash colors, add the foreground shadow patterns on the steps with the no. 8 round. These colors need to be rich and concentrated, values 6 through 10 to add contrast. Pull out the light edge of the steps with a damp brush. Also do the same for the grout areas, using a small, damp brush and blotting with a paper towel.

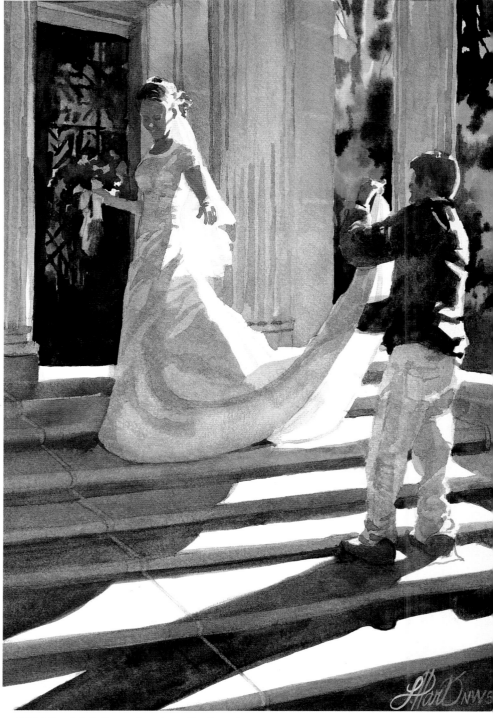

5 Add final details, and make adjustments

Add the indication of texture to the columns behind the bride with a mixture of Alizarin Crimson, Manganese Blue and Transparent Oxide Red. Darken the pillar on the far left.

Step back, and evaluate your efforts. Do the dark values of the second wash seem to make the first-wash colors glow? Did you achieve the effect of the bride coming forward in space against the dark background? If not, rewet the dark areas, and float in a darker value.

SETTING UP THE SHOT
14" × 11" (36CM × 28CM)

To love what you paint, paint what you love

Chapter Nine Summary

- Paintings can freeze the moment for us to relive over and over.

- Paint around white shapes rather than relying on masking fluid.

- You can use arbitrary color when painting from black-and-white photos as long as you get the values accurate.

- Using muted brown tones for painting historical subject matter will give the feeling of old sepia photos.

- Use the pull-down technique to paint simple, believable people.

- Portraying a figure's abstract light-and-shadow pattern will make it appear more real from a short distance.

- Keep values dark enough in the second wash to make the first-wash colors glow.

In his classic *Acres of Diamonds*, Russell H. Conwell tells the story of a rich man, Ali Hafed, in ancient Persia who heard that if he could find a diamond the size of his thumb, he could purchase much more land than he already had. So he sold his property, left his family and went in search of valuable diamonds. Ironically, while he was gone, the new owner of his property discovered diamonds buried in the white sands of the land he abandoned. Had he remained home and dug in his own fields, he would have been well rewarded.

Like Ali in the story, we often search for exotic subject matter to paint, while overlooking the most valuable sources of all right at home. When we paint what we love and are most familiar with, there will be a passion and honesty to our paintings that will give them genuine worth.

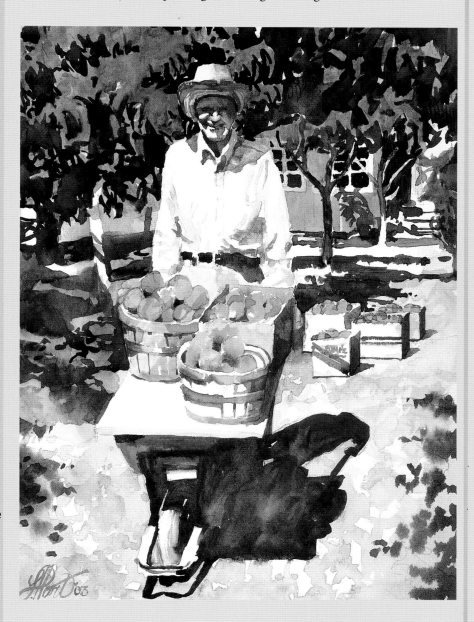

My father has a beautiful peach orchard that he still cultivates with pride and joy. Every year relatives and friends from around the country look forward to receiving his peaches. This orchard is his way of leaving something of himself behind so that future generations may benefit. To me, these trees represent his life, a branch of which I am, and the peaches, the countless acts of service he has shared with so many people.

FAMILY TREES
14" × 11" (36CM × 28CM)
COLLECTION STANLEY AND LEOLA SMITH

Some words in parting

As I came to the conclusion of writing this book, I felt a great relief and satisfaction in letting it go but also a strange yearning to call it back and start all over again. Maybe it's a little like the feeling of a parent when it comes time to let a grown child leave the nest, which I also did during the course of writing this book. You know it's time, but it's still hard to let go. The parental sentiment of "There's still so much I wanted to tell you!" seems to brood over this project even upon its completion.

But perhaps my yearning to go back also stems from another reason: the old adage that the teacher learns more than the student. Writing a book opens you up to teaching yourself, and I have learned so much through the intensive soul-searching this project has required, as well as through distilling nearly two decades of personal study to a few short chapters of important truths. Now that I'm finished, I feel like I finally have something valuable to say! I have heard that teaching is simply creating a space where truth can dwell, so if I have at least opened your mind to the concepts presented in this book, I will feel I have been successful.

As you follow your own creative path, enjoy the process. Don't be afraid of failure, as it truly can be a friend. Sometimes we learn more from those paintings that fail miserably than those that succeed too easily. You'll reach success by climbing the ladder with rungs made up of your own mistakes.

If you persistently pursue your creative dreams as an artist, I promise you'll receive added help and inspiration from another Creator who is interested in your success. Pay attention as you work, and you will begin to see that little miracles happen regularly in your behalf.

If you're just beginning, be patient with yourself, and remember that every artist was once in your shoes. Don't give up, and don't let anyone's criticism deter you. The painting I brought home from my first watercolor class was a total disaster! I made the mistake of leaving it on the kitchen table and found it the next morning bearing this message in my husband's handwriting: *Urgent! See Me!* signed, *the teacher.* I nearly collapsed with laughter and have since learned that injecting a little humor can help to soften a blow.

Becoming successful as an artist has much more to do with desire than it has to do with talent. Sue Monk Kidd expressed it this way. "Actually, you can be bad at something … but if you love doing it, that will be enough." If you love painting and keep at it, it will be enough.

Live a life that is rich in love and full of gratitude. Don't let your artistic pursuits become a vacuum pulling you away from life and loved ones. Your life and your loved ones are the substance of your art, whether they are the subject or not, so to abandon them is to lose the passion that drives you to paint. Some artists become hermits, thinking they must give up everything in order to learn to paint, but whether we know how to paint is not as important as if we have something to paint about. We need, as Lloyd D. Newell said, "something that stirs our souls and lifts our thoughts to God. Most often those who feel like singing are they … who glory in the wonders of everyday life and find ways to keep their own creativity alive."

My wish for you is that painting will stir your soul and that your love and gratitude for life will give your brush a song to sing.

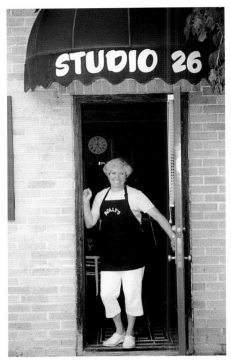

Thank you for letting me share my thoughts and paintings with you.

If anyone had told me as a beginning artist, years ago, that a painting of mine would one day receive an award in a national exhibition, I would have laughed out loud. Now I have a different philosophy: If you hold on to your dreams and work your hardest, you can achieve the impossible. This painting won the 2005 Gold Medal of Honor in the 138th Annual International Exhibition of the American Watercolor Society.

MAYBE HE'S JUST LATE
21" × 29" (53CM × 74CM)

Index

The **best in art instruction**
comes from North Light Books!

Designed to be a mainstay in your water-color resource library, this easy-to-reference guide covers everything you need. Step inside the studio of a master for a one-on-one watercolor workshop. *Lessons From a Lifetime of Watercolor Painting* brings together the time-tested tips, tricks and techniques gained from 50 years of painting. A professional artist and teacher, Donald Voorhees shares his unique mastery with clear, step-by-step instruction you can easily apply to your own work.

ISBN-13: 978-1-58180-775-2,
ISBN-10: 1-58180-775-9, HARDCOVER,
#33446

Created specifically for artists and art lovers, *Splash 9: Watercolor Secrets* invites you to discover watercolor on a deeper level, providing detailed commentary from the artists themselves on every piece. You'll learn about their influences, their challenges and, most importantly, their specialized painting techniques.

ISBN-13: 978-1-58180-694-6,
ISBN-10: 1-58180-694-9, HARDCOVER,
#33353

In this inspiring book, Joyce Roletto Faulknor shares her proven secrets for sharpening your senses and transforming your observations into striking interpretations of light's interaction with glass. Learn to begin painting shapes and values, working dark to light. Building luminosity one layer at a time, you'll capture the textures of light and glass with new resonance and realism.

ISBN-13: 978-1-58180-753-0,
ISBN-10: 1-58180-753-8, HARDCOVER,
#33420

These books and other fine North Light titles are available at your local fine art retailer, bookstore or from online suppliers. Or visit us at www.artistsnetwork.com.